At Home with the
BRONTËS

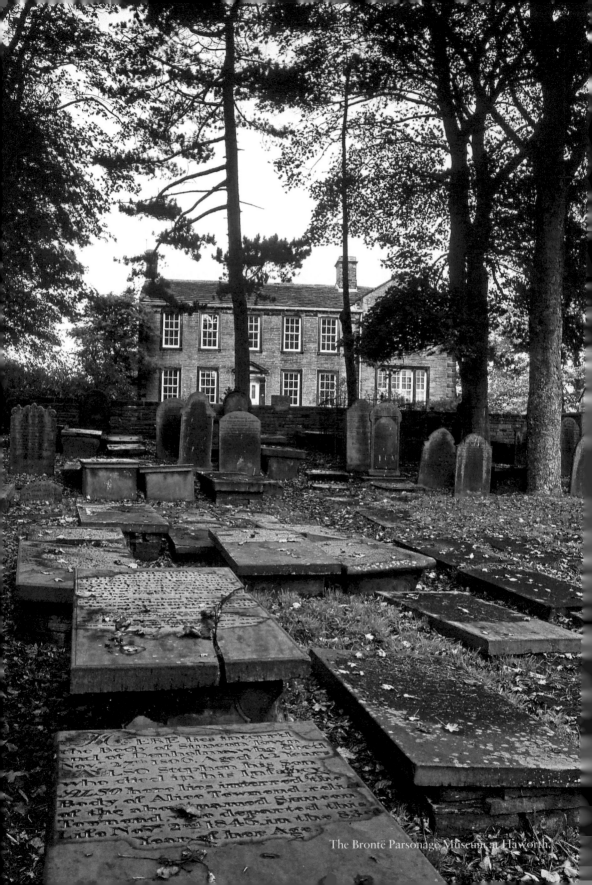

At Home with the BRONTËS

The History of Haworth Parsonage and its Occupants

ANN DINSDALE

AMBERLEY

About the Author

Ann Dinsdale is Collections Manager at the Brontë Parsonage Museum, Haworth. She lectures and writes on all aspects of the Brontës' lives, and social conditions in mid-nineteenth century Haworth. She is the author of *The Brontës at Haworth* and a contributor to *The Brontës in Context*, published by Cambridge University Press in 2012.

First published 2013

Amberley Publishing
The Hill, Stroud
Gloucestershire, GL5 4EP

www.amberley-books.com

British Library Cataloguing in Publication Data.
A catalogue record for this book is available from the British Library.

ISBN 978 1 4456 0855 6

Typeset in 10pt on 12pt Sabon.
Typesetting and Origination by Amberley Publishing.
Printed in the UK.

Contents

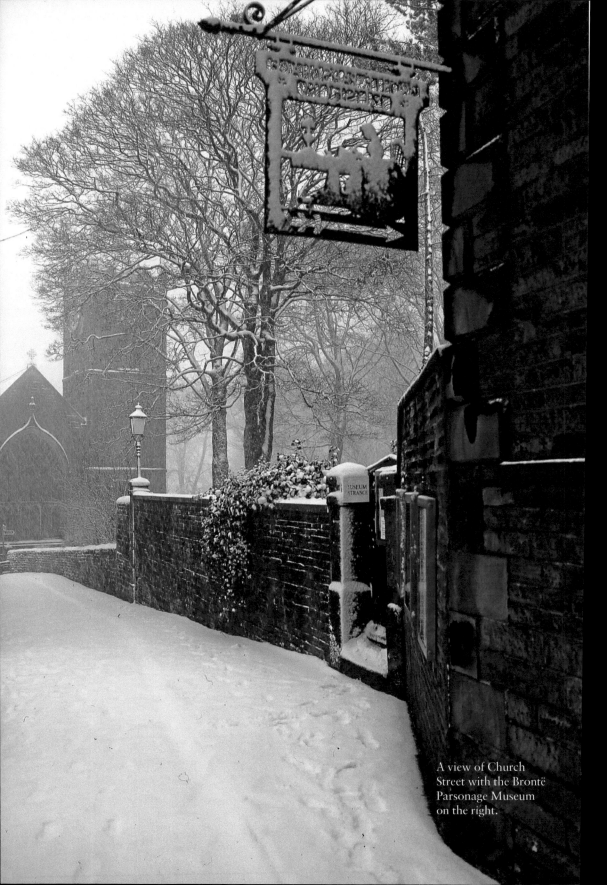

A view of Church
Street with the Brontë
Parsonage Museum
on the right.

Acknowledgements

I would like to thank the following who have supplied photographs and helped me in the writing of this book: Julie Akhurst, Helen Broadhead, the Brontë Society, Jean Bull, Caroline Chapman, Liz Gorman, Jill Greenwood, Robin Greenwood, James Hutton, Sarah Hutton, Sarah Laycock, Eric Mitchell, Trevor Mitchell, Catherine Prince, Margery Raistrick, Andrew Schofield, Sally Stonehouse and Christine Went. My daughter, Emily Dinsdale, read the book in manuscript and made suggestions, and I owe a special debt of gratitude to Helen Johnson and Steven Wood, who provided valuable information and advice. I would also like to take this opportunity to thank the staff and volunteers of the Brontë Parsonage Museum, past and present, and to them I dedicate this book.

Foreword

Haworth Parsonage is the world-famous home of the Brontë family. The house was built in 1778–9 as a residence for the incumbent minister at St Michael and All Angels church, and was occupied by the Brontë family from 1820 to 1861, during which time Patrick Brontë held the position of Perpetual Curate at the church. The Brontës spent most of their lives in Haworth, and the Parsonage and its surroundings were central to their creative lives. It was the place in which they grew up, where they began writing as children, where they wrote their great novels and poetry, and where they died.

It is usually forgotten that Haworth Parsonage has also been home to several other families. Patrick Brontë was not the first incumbent to live in the house, and after his death in 1861, the Parsonage became home to four of his successors before being acquired by the Brontë Society in 1928. Thereafter, it became home to four museum custodians and their families. All of these later occupants witnessed the development of tourism in Haworth, which had begun in Mr Brontë's own lifetime, and experienced the trials and tribulations of living in a literary shrine.

The idea for this book came about over ten years ago when I first met Trevor and Eric Mitchell at an event held at the Brontë Parsonage Museum. Their father was Harold Mitchell, the Museum's first Custodian, and both brothers were born at the Parsonage: Trevor in 1930 and Eric in 1935. I got to know Eric well, and was fascinated by his stories of growing up at the Parsonage. I tried, unsuccessfully, to persuade him to write an account of those years but eventually he suggested that I should write one instead. About this time I also came to know Joanna Hutton, a former curator at the Parsonage, who had lived in a flat on the museum premises, and who also had a fund of wonderful stories to tell. Joanna had written a lively account, *Memories of a Brontë Curator*, which looked likely to remain unpublished following her death in 2002. Jean Bull, a former trustee of the Brontë Society, came forward with information about her father, Norman Raistrick, the last live-in

custodian at the Parsonage, and the idea for a book gradually took shape and began to expand. I have received a great deal of support from Jean Bull, the Hutton family and the Mitchells, although sadly, Trevor Mitchell died in September 2012, shortly before the book's completion. Having researched and written this book, I no longer think of the Parsonage only in association with the Brontës. Its rooms are now peopled by all those others who have lived in the house, and this is their story.

Ann Dinsdale
Haworth, November 2012

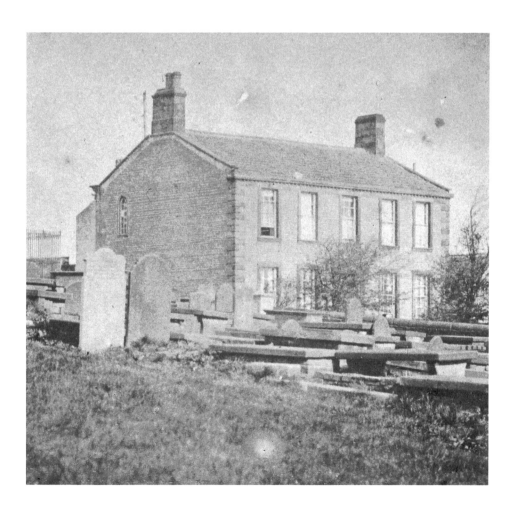

Haworth Parsonage: A Chronology

Period	Occupant	Alterations/work carried out
1778–1779		The Parsonage is built.
1779–1791	Revd John Richardson	No records of any work carried out in this period.
1791–1819	Revd James Charnock	No records of any work carried out in this period.
1820–1861	The Brontë family	
1833		Ellen Nussey describes the Parsonage walls as 'not papered but stained in a pretty dove coloured tint'. She also notes that there 'was not much carpet anywhere except in the dining-room, and on the study floor. The hall floor and stairs were done with sand-stone...'
1843 (May)		William Wood's accounts show: 'To 1 rom papring and sise' [room papering and sizing].
1850		The Parsonage is re-roofed.

The dining-room is believed to have been enlarged at this time by moving the wall out into the hall and reducing the thickness of the wall. Charlotte's room was similarly enlarged by reducing the size of the children's study. The doorway to Charlotte's room originally faced that of the room opposite and was probably moved at the same time.

The dining-room is redecorated. In 1853 Mrs Gaskell noted the room has 'evidently been refurbished within the last few years ... the prevailing colour of the room is crimson, to make a warm setting for the cold grey landscape without'. She also mentions 'the high, narrow old-fashioned mantel-piece' with the recesses on either side filled with books.

Mr Brontë's notebook records that 'in 1850 and 1851 I got the rooms painted and stained for just about £4 and from what I have seen they ought to do for at least 1860'.

1854

Charlotte converts the store room into a study for Arthur Bell Nicholls. A fireplace is added and an outside chimney built. According to Jocelyn Kellett this work 'necessitated blocking half the stone mullioned window in this room also the one above in Tabitha's room [the servant's room] and in order to give light to these a window was put in each room in the gable end'. Kellett also suggests that the mullioned window in the servant's room may have been blocked to avoid window tax.

In Charlotte's letter of 21 May 1854 she writes, 'The green and white curtains are up – they exactly suit the papering.'

1861–1898 Revd John Wade

1861

In a letter dated 11 November, Charles Hale reports on work being carried out at the Parsonage: 'The new incumbent does not choose to go into a rotten old house, but they are doing very much more than making merely necessary repairs. They are putting in fireplaces and mantelpieces of marble, and windows of plate glass ... the masonry is new pointed and the house will be refitted anew throughout.' Hale also carried away 'plenty of the moulding or woodwork that went about the rooms', suggesting that the rooms had wainscots in the Brontë period. This is borne out by Gaskell, who writes, 'The Parsonage was built at a time when wood was plentiful, as the massive stair banisters, the wainscots, and the heavy frames testify.'

Hale also refers to the blocked window in the servant's room: 'In old Tabby's chamber for some reason, half the window had been walled up with a stone wall by Mr Brontë's direction; this erection has been pulled down.'

According to Jocelyn Kellett, at some point 'the ground-floor level was raised by about 5 inches by laying a wooden floor over the existing flags in the study and dining-room as this made the rooms warmer. However, this necessitated raising all the other flagged floors to the same level.'

The level of the backyard has been raised by approx. 1½ feet since the house was built.

1863

William Wood's accounts show 'many repairs' were carried out for Wade.

1872–1936	The level of the long staircase window is raised between these years. Part of the outside stone sill which can still be seen is 3 feet lower than the present window bottom.
1878	A large gabled wing with a cellar below and a large rear extension are added to the Parsonage to plans drawn by Messrs Milnes & France in 1872. This results in the loss of the mullioned window in the original kitchen, which becomes a passageway to Wade's new dining-room.
	The kitchen doorway is altered to form a pointed arch, and the arched recess on the staircase where the clock now stands is added to provide access to Wade's new bathroom. The arches in Branwell's studio date from this time.
1890s	In an article published in 1928, Mrs Chadwick recalls visits to the Parsonage made 'some forty years ago': 'The Parsonage is now much larger than it was in the days of the Brontës, a long dining-room, two bedrooms, a kitchen, and two bathrooms having been added … [the dining-room] is some four yards square. The old fireplace has been replaced by a modern grate, and the two window seats … are gone.' In Charlotte's room 'the same old fireplace is still there'.
1899	In a book published in 1899, Marion Harland recounts a visit to the Parsonage in Wade's time. Mr Brontë's study is now Wade's study and she writes, 'Paper of a soft neutral tint conceals the rough walls.' The current library is described as 'a large, cheery, handsome library-parlour'.
1898–1919	T. W. Story
1919–1925	Revd G. A. Elson

1925–1928	Revd J. C. Hirst	
1928	The Brontë Society	

1928	A letter to Mr Mossman dated 11 June 1928 reads, 'We have all the estimates and particulars completed regarding the renovation, heating, lighting and decorating ... The builder and Clerk of Works is Mr E. Turner of Messrs E. Turner Ltd, Bradford Street, Keighley...'
	A survey by the architects Kitson, Parish & Ledgard advises laying a concrete floor in the dining-room as a fire precaution. The ceiling is treated in a similar fashion and the door reinforced with steel.
1933	A bathroom added by Revd Wade is removed to create extra storage.
1936	By this date the old peat house which stood in the northern corner of the backyard has been demolished.
1937	An estimate of £50 is accepted for painting inside the Parsonage; 'Mrs McCracken & Mrs Edgerley are to see the painter at Keighley & decide on the colour – probably Caen.'
1955	The steps to the front door have subsided by more than 3 inches and are re-set. Presumably they are settling back to their original level.
1957–1961	An extension is added to the rear of the Parsonage to provide accommodation for the custodian. The plans are drawn up by Messrs Jones & Stocks of Leeds in 1957, and include a glass loggia to connect the extension with the Parsonage.
1958	The Brontës' privy is demolished, as it is considered beyond repair.
	The plate-glass windows dating from Wade's time are replaced with small panes.

The dining-room and Charlotte's room are decorated in papers which are 'of similar taste' to the samples found in Charlotte's writing desk. Mr Nicholls' study is papered in green and white, and Branwell's studio is decorated using a wallpaper copied from a sample found there during the stripping process.

Layers of paint are removed from the hall; the lowest layer is found to be pale blue.

An old grate found in the cellar is fitted to the fireplace in Mr Brontë's study, which is reconstructed by Mr Mitchell in 1956. An Edwardian fireplace in the dining-room is replaced by an 1820s marble mantelpiece from Methley Hall.

1962

In response to a letter in a newspaper, Donald Hopewell writes, 'As for the decoration which so excites your correspondent, it is the fruit of long research and for all of it there is ample warrant. The "screaming blue paint" was matched from that on the woodwork of the Brontës' day, discovered under layers of later colour and obscuring the fine lines of door cases, arch and architrave. The wall papers were copied from patterns belonging to Charlotte and from strips still adhering to the walls under many later additions…'

1976

The entire roof is removed and replaced. New beams and purlins of double thickness are fitted.

The bedroom ceilings and cornices are renewed, faithfully reproducing those found there.

Repairs carried out in the servant's room reveal the blocked-up window. According to Kellett, 'at the side of this window the old plaster was found to have been painted in an amateur fashion in matt paint. The colours used were a sea green flecked with rose pink.'

1980	A new floor is laid in Branwell's studio. The wallpaper is all stripped and then the room is redecorated. The paint on skirting boards is burnt off and they are re-painted. The handrail is stripped and varnished.
1984	Picture rail in the dining-room is removed and replaced with a waist-rail. The walls are papered above the rail with 'Scarborough' design paper supplied by Woods of Harrogate.
1985	Mr Brontë's bedroom is papered with 'Londonderry' design wallpaper. New floorboards are laid in Charlotte's room. The archway in the hall and the ceiling are replaced.
1987	A new wallpaper is introduced to Mr Nicholls' study based on a design found in Charlotte's writing desk. Period wallpapers are introduced throughout the original rooms and an attempt is made to turn the Parsonage into a home. The picture rail in Charlotte's room is replaced by a waist-rail.
2009	The Exhibition Room on the upper floor of the Wade wing is redeveloped.
2011	An analysis of decorative finishes is carried out by Crick Smith University of Lincoln, and a new decorative scheme based on their findings is put together by Allyson McDermott.
2013	The new scheme is carried out during the Museum's closed period in January. All the rooms of the original Parsonage are redecorated to more closely resemble their appearance in the Brontë period.

Before the Brontës: 1778–1819

The name of Haworth, would scarcely be known at a distance, were it not connected with the name of Grimshaw.

John Newton, *Memoirs of the Life of the Late Rev. William Grimshaw, A. B.*, 1799.

Haworth had already attracted fame almost 100 years before the Brontë family's arrival in the village, when it came under the ministry of the Reverend William Grimshaw (1708–63). Grimshaw was a leading light in the eighteenth-century Evangelical Revival, and colourful accounts abound of him haranguing sinners and driving his parishioners from public house to church, brandishing a horsewhip. According to Grimshaw's biographer, John Newton,

> In the year 1742 [Grimshaw] was removed to the perpetual curacy of Haworth, near Bradford in Yorkshire, to preach to a people, who, when he went among them, were very ignorant, brutish, and wicked. But very soon, by the blessing of God upon his ministry, this wilderness assumed the appearance of a fruitful field, and the desart rejoiced and blossomed like the rose.

Haworth was one of a number of chapelries which made up the parish of Bradford, and until it became a parish in its own right in 1864, the incumbent was always the Perpetual Curate rather than the rector. Nominally, the Vicar of Bradford was the patron of the living at Haworth; however, the money which paid the incumbent's stipend came from a local trust which drew rents from five farms it owned in Stanbury. The Trustees for Church Lands, who administered these Stanbury estates, reserved for themselves the right to a say in the nomination of a minister, and had the option of withholding the income if their views were not consulted.

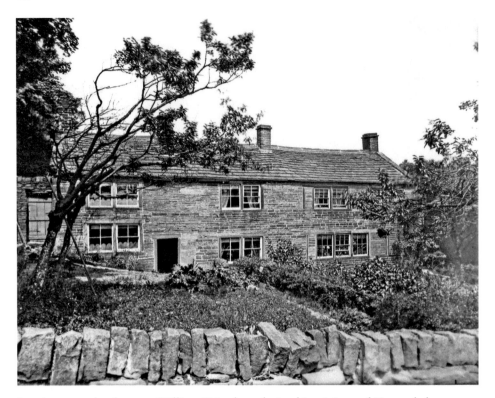

Sowdens served as home to William Grimshaw during his ministry of Haworth from 1742 until his death in 1763.

A photograph showing Haworth old church and Parsonage, *c.* 1860. The Sunday school and adjoining sexton's house were built in 1832 during Patrick Brontë's incumbency.

John Richardson (1763–91)

There was no official parsonage house at Haworth until late in the eighteenth century, and during his incumbency Grimshaw lived at Sowdens, an old stone farmhouse on the edge of the moors. Grimshaw had been named by John Wesley to succeed him as the leader of the Methodist movement within the Church of England, but in the event, Grimshaw predeceased the Wesleys and died at Sowdens in 1763. The Reverend John Richardson, Grimshaw's successor, is said to have disliked Sowdens and initially continued to live at his previous cure in Huddersfield, appointing a resident curate for Haworth. When he eventually made the move to Haworth he is believed to have lived at the Manor House at Cook Gate.

By 1778 the land on which the Parsonage now stands had been acquired by the Church Lands Trustees, and by August of that year, work had begun on the construction of the house. Haworth Parsonage, or Glebe House as it was originally known, was built of millstone grit, quarried from the moors behind the house. The names of the architect and builder are not known, but it's possible that Richardson had some say in the design of the new parsonage house, which shares the same proportions and classical façade as the Manor House at Cook Gate. It is also strikingly similar to Mossgill House in Crosby Garrett, Cumbria, where Richardson was born and where his family still lived.

Haworth Parsonage is believed to have been completed in 1779, and Richardson became the first occupant. The house is set above the village and separated from it by the church and a square plot of garden. To the rear of the property was a backyard with a privy and a range of outbuildings. It appears that the barn, which formerly stood across the lane from the Parsonage, was also part of the Parsonage property at that time. There is a central pedimented doorway with two sash windows on each side and five windows on the first floor. The back of the house was less grand, with the mullioned windows typical of farmhouses and cottages in the district. The front door leads into a flagged entrance hall, and probably when the house was built, flagstone floors would have extended to all the ground-floor rooms. There are two larger rooms at the front of the house – the one on the right which later became Patrick Brontë's study, with the kitchen behind, and a room on the left of the hall, which came to serve as the Brontë family's living-/dining-room. Behind this room was a store room, with access to the backyard. One flight of stone stairs leads from the hall down to the double-vaulted cellar, while another leads to the five bedrooms above. There are two large bedrooms at the front of the house with a small room squeezed between, which possibly served as a dressing-room in Richardson's time. The two smaller rooms at the rear would have been occupied by servants. We know nothing of how the rooms were furnished, but they are likely to have appeared to be fairly austere, with their stone floors and walls painted in shades of off-white and stone-coloured distemper.

John Richardson was born in 1734. The Richardsons were a prominent land-owning family and his parents, Joseph Richardson (*c.*1696–1764) and Deborah Kirke (1704–1759), were both of old, dissenting families. A few years after John's

birth, the family's home, Mossgill House, was rebuilt. It still stands today, an attractive, symmetrical house with a stuccoed front and slate roof. A barn is attached to the house, and the family owned much of the surrounding land. In 1751 part of the house was licensed as a place of religious worship, and it was in this atmosphere that Richardson and his siblings grew up. John had two older brothers, Joseph and Richard, and younger brothers Thomas, Henry and William. An only sister, Ann, had died in childhood the year before John's birth, and Henry died as a baby in 1740. Not surprisingly given the strong religious element in their upbringing, William, like John, entered the Church.

Richardson was educated at the school in Sedbergh before going up to Queens College, Oxford, gaining a BA degree in 1761 and MA degree in 1764. Following ordination he began his career as curate to Henry Venn, Vicar of Huddersfield, and one of the leading Evangelicals in the north. Venn was a great friend of Grimshaw and had preached his funeral sermon. Such strong Evangelical credentials made John Richardson an ideal candidate for the living at Haworth following Grimshaw's death, and he was appointed Perpetual Curate on 10 September 1763. In 1766 Richardson was also appointed Perpetual Curate of Baildon, where he was aided by a series of assistant curates and never actually took up residence. One of his assistant curates was his youngest brother William, who, following an illness, appears to have become the first person to die at Haworth Parsonage in 1788, at the age of forty-four.

At this distance in time, John Richardson has become a shadowy figure. An account of him by a former servant, which appeared in the *Keighley News* on 26 August 1865, provides some personal detail:

> He was a very exemplary man in his sacred duties. He was also a very handsome gentleman, and strong in appearance; generally dressed very neat, and wore a powdered wig, which was fashionable for clergymen at that time, similar to what is now worn by judges and barristers at this day, and he mostly wore a clerical three-cornered hat, and wore his bands regularly on week days, when visiting his parishioners. He was never married, except to his church and his people. In his time there was a favourite spot, named Folly Spring, in the valley, adjoining Bridge house, which had one of the strongest springs in the locality, and where a convenient place once stood, as a place to undress in for bathing purposes. In summer time he often bathed in that crystal spring of water, which has been considered by some to be as cold and as useful as Ilkley wells for healthful purposes.

An obituary which appeared in the *Gentleman's Magazine* describes Richardson as 'a man of polished manners, of the most unaffected piety, and of a mild and amiable disposition'. In addition to all these attractive qualities, Richardson possessed a private income and must have been much sought after as a marriage partner. He owned property in the Haworth area, including Marsh End Farm, and in 1783 he inherited property in Derbyshire following the death of his elder brother Richard. Jane Meyer, a widow living in Richardson's curacy at Baildon, is said to have taken

THE

BLESSEDNESS

OF

DYING IN THE LORD:

A SERMON.

PREACHED IN

HAWORTH CHURCH,

MAY 23, 1791.

Occasioned by the DEATH

OF

The Rev. JOHN RICHARDSON, M.A.

Late MINISTER of that CHURCH.

By the Rev. MATTHEW POWLEY, M.A.
VICAR of DEWSBURY, YORKSHIRE;

And published at the REQUEST of the CONGREGATION.

Precious in the Sight of the Lord is the Death of his Saints.
PSALM cxvi. 15.

——— Smitten Friends
Are Angels sent on Errands full of Love:
For us they languish, and for us they die.
DR. YOUNG.

LEEDS:

PRINTED FOR J. BINNS, AND SOLD BY HIM,
AND J. WALLIS, LONDON; W. TESSEYMAN, YORK; N. BINNS,
HALIFAX; AND ALL THE BOOKSELLERS OF BRADFORD,
WAKEFIELD, HALIFAX, KEIGHLEY, BARNSLEY,
PONTEFRACT, HUDDERSFIELD, &c.
1791.
(*Price SIX-PENCE.*)

A copy of the funeral sermon preached at Haworth on John Richardson's death in 1791.

such a strong fancy to him that she proposed marriage and left him £1,000 in her will. A further reference to Richardson appears in the Jane Austen-like correspondence between Malley Horsfall of Haworth and her cousin, Sally Ramsden of Mixenden, near Halifax. In a letter dated 30 May 1774, Malley writes, 'Mr Richison *did* marry Miss G. and Mr North … and very merry he was about it. He came to dine with them. He seemed much enjoyed and sat up till 10 o'clock … and talked much. It is expected he will marry Miss Booth soon…'

John Richardson never married, and died at the Parsonage on 23 April 1791, at the age of fifty-six. According to Story's *Notes on the Old Haworth Registers*, his cause of death was recorded as 'decline', a commonly used catch-all term for various wasting diseases including tuberculosis. Our informant at the *Keighley News* writes that he 'was taken to bury to his ancestors' burial place, at the village of Crosby Garrett, near Kirkby Stephen in Westmoreland, which must have been rather a difficult journey at that time, with what was called a "horse litter". Many of his devoted parishioners followed his remains for some miles on the parting and mournful occasion.'

Although John Richardson never achieved the fame of William Grimshaw, his popularity in Haworth was such that it was hoped his nephew, the Reverend Joseph Richardson, would succeed him as the next incumbent. According to Horsfall Turner, 'great dissatisfaction was manifested that he did not succeed to the curacy'.

James Charnock (1791–1819)

The next incumbent at Haworth was the Reverend James Charnock, who was thirty when he moved into the Parsonage. He was born in 1761, the eldest of the three sons of Thomas and Mary Charnock (*née* Hanson). His grandfather, also called James, had built and become landlord of the Ginn Pit Inn at Soil Hill, in Ovenden township, near Halifax. James's father inherited the inn in 1759 and took over as landlord. He also acquired a joint share in Swilling End coal pits and other associated property.

James Charnock went up to University College, Oxford, and gained a BA degree in 1784 and MA degree in 1787. At the time of his appointment to Haworth in 1791, he is believed to have been curate at Reading, Berkshire. Most of Charnock's family connections were in West Yorkshire, and one of his brothers, Joseph, became incumbent at Heptonstall in 1803, and headmaster of the grammar school there.

In 1797 Charnock married Mary Barraclough, the daughter of Thomas Barraclough and his wife Mary Brooksbank, of Manningham, near Bradford. In due course, Mary inherited property in the Bradford area which meant that Charnock, through both his wife and his own inheritance, became a man of independent means. In 1808 he acquired and let Charles Mill in Far Oxenhope, which for a time was known as Charnock's Mill, and he owned other property in the local area including the older of the two farms at Rush Isles, Stanbury (known as Johnny Lad's house). It has been suggested that he did not occupy the Parsonage himself for all the twenty-eight years of his incumbency, and he has been listed as the occupier at Rush Isles.

Mossgill House at Crosby Garrett in Cumbria, home of the Richardson family.

This seems highly unlikely; his other properties would not have provided him with such a convenient and suitable home as Haworth Parsonage.

The Charnocks had four children: Maria, their first daughter, born in March 1799, who died just a few weeks later; an only son, Thomas Brooksbank, who was born on 28 January 1800; Mary Hodgson, born on 5 November 1802 and Martha Hanson, born on 29 March 1807. Mary did not long survive the birth of this last daughter; she died on 14 July 1809, aged thirty-seven. On 18 September 1814 Charnock married for a second time. His bride was Grace Sugden, one of the children of Thomas and Mary Sugden of Mytholmes, and the marriage took place at Haworth.

Following a long illness, James Charnock died on 25 May 1819, aged fifty-seven. According to an entry in the registers dated 31 May 1819, he was buried inside the church. There is no surviving monumental inscription and his name is not included among those in the faculty of 1879 whose graves were to be disturbed during the rebuilding of the church. Presumably his tomb, like that of the Brontës, was left undisturbed and concreted over at that time. Although the exact site of his burial is not known, his funeral feast was long-remembered in Haworth and is referred to by both Elizabeth Gaskell and J. W. Laycock:

> At the funeral of the Rev. J. Charnock, the second minister of Haworth in succession to Mr Grimshaw, in 1819, about eighty people were bidden to the arvill, or funeral

feast, the cost of which averaged 4*s* 6*d* per head, a considerable item in those days, all of which was defrayed by the friends of the deceased.

Following her husband's death, Grace Charnock had to leave the Parsonage. She never remarried, and at the time of the 1841 census, was living with William Marten, a wool merchant, and his family, at Manor Row in Bradford, where she died from typhus fever on 25 December of that same year, at the age of fifty. She was buried in the churchyard at Haworth on 30 December 1841, her funeral service conducted by Patrick Brontë.

Charnock's only son, Thomas Brooksbank, took a master's degree at Oxford and followed his father into holy orders. Being of independent means, he held no living but often officiated at Haworth church, and was well known to Patrick Brontë. In late October 1847, at the age of forty-seven, he committed suicide by hanging himself in the dressing room of his home at Cullingworth. Although as a suicide Charnock could have been refused a church burial, he was buried in the churchyard at Haworth and Patrick Brontë conducted the funeral himself.

It is not known what arrangements were made for Charnock's two surviving daughters in the immediate aftermath of his death. Mary Hodgson Charnock ended her days in London, dying on 15 December 1845 at the age of forty-two, from hydrothorax, a condition usually linked to disease of the liver. Martha Hanson Charnock married Thomas Horsfall, a merchant, in 1835, and Mary Hodgson had been sharing their home at 10 Grove End Road in the Marylebone district at the time of her death. It appears that Martha and Thomas travelled in the early years of their marriage; the eldest of their two daughters, Sophia, was born at Baden-Baden in Germany. By 1851, Thomas was described as a 'Gentleman Farmer and Landed Proprietor', living with his family and an accompaniment of servants at Burley Hall, near Otley. Thomas died in 1861 and Martha spent the rest of her life at the hall, for most of that time living with her daughter, Sophia Crofton, also widowed. Martha was the only one of Charnock's children to survive into old age. She died as a result of 'natural decay' on 24 September 1891, aged eighty-four, at her home in Burley.

In his study of *Methodist Heroes in the Great Haworth Round*, J. W. Laycock offered the following assessment of the first occupants of Haworth Parsonage: 'The successors of Grimshaw, the Revs John Richardson and James Charnock, were regarded as Evangelical in their principles, and as having preached the truth; but they were far behind the never-to-be-forgotten apostle of Northern Methodism.' Nowadays the names of Richardson and Charnock are best remembered not as successors of Grimshaw, but as predecessors of the next incumbent, Patrick Brontë.

The Brontës at Haworth:
1820—1861

My home is humble and unattractive to strangers but to me it contains what I shall find nowhere else in the world – the profound, and intense affection which brothers and sisters feel for each other when their minds are cast in the same mould, their ideas drawn from the same source – when they have clung to each other from childhood and when family disputes have never sprung up to divide them.

Charlotte Brontë letter to Revd Henry Nussey, 9 May [1841].

Following Charnock's death, Henry Heap, the Vicar of Bradford, lost no time in nominating Patrick Brontë, Perpetual Curate of Thornton, as his successor. The Haworth Church Lands Trustees bitterly resented the fact that they had not been consulted over the nomination, and announced that they would resist the vicar's choice. Mr Brontë sought advice from one of the trustees, Stephen Taylor of Stanbury, and on learning the true state of affairs at Haworth, he decided to resign. Again without reference to the trustees, Heap next nominated Samuel Redhead, who arrived in Haworth on 31 October 1819 to take up his first duty. Although the trustees had no complaint against Redhead personally, he was resented as the vicar's choice. The entire congregation walked out of his service, and the following week there was so much noise and disruption he was unable to continue. Armed with a threat from the Archbishop of York, which stated that the church would be shut up if there was any further disturbance, Redhead made one more attempt to take duty at Haworth. He was once again driven from the church and tended his resignation the following day. Having made their point, the trustees were then content to join with the Vicar of Bradford in nominating Mr Brontë. Once he had gained the support of both parties, Patrick Brontë accepted.

In February 1820 Patrick Brontë was finally appointed Perpetual Curate at Haworth, and in April he moved into the Parsonage with his family. The Brontës and their household goods were transported from Thornton in seven horse-drawn carts, loaned for the occasion by Stephen Taylor. The family were accompanied by

their two young servants, Nancy Garrs and her sister, Sarah, but even with their assistance, the move must have been a great trial for Mrs Brontë, still frail after the birth of Anne on 17 January, and with five other small children to care for. Once the difficult journey was over, the family's furniture and belongings would have to be unpacked and arranged, and the house must have been cold and damp after being left uninhabited over the winter. 'One wonders,' reflected Mrs Gaskell, writing many years later, 'how the bleak aspect of her new home – the low, oblong stone parsonage, high up, yet with a higher backdrop of sweeping moors – struck on the gentle, delicate wife whose health was even then failing.'

As far as the Brontës are likely to have been concerned, their new home was one of the better houses in the village and offered more space than their previous home at Thornton. The family's new life at Haworth did not start out happily, however, for it soon became clear that Mrs Brontë was terminally ill with what is believed to have been cancer of the uterus. For the next few months she was confined to her bedroom while the children played quietly in another part of the house. Mr Brontë engaged a local woman, Martha Wright, as nurse, and she recalled how on her better days, Mrs Brontë would ask to be raised up in bed so that she could watch her clean the grate, 'because she did it as it was done in Cornwall'. When Maria Brontë died on 15 September 1821, her husband and sister were at her bedside and her small children gathered at the foot of the bed. Her mind was 'often disturbed' in the last conflict, wrote Mr Brontë, adding that she died, 'if not triumphantly, at least calmly and with a holy yet humble confidence that Christ was her Saviour and heaven her eternal home'. In later years, Charlotte could only bring to mind a single memory of her mother: seeing her in the evening light, playing with her young son Branwell in the Parsonage dining-room.

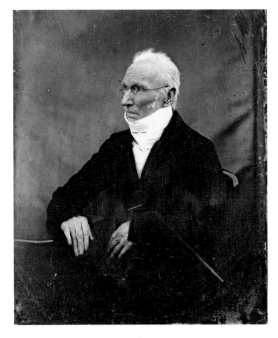

One of several photographs of Patrick Brontë taken late in his life.

Domestic Life at the Parsonage

Towards the close of the nineteenth century, Sarah Garrs was interviewed by Marion Harland for her book, *Charlotte Brontë at Home* (1899), for which she provided an account of the Brontës' domestic routines in those early years at the Parsonage. Every morning, after they had been washed and dressed, the children went to their father's study for prayers. Prayers over, Patrick would join his children for breakfast in the dining-room. This meal was described by Sarah as being 'plain but abundant', consisting of 'porridge and milk, bread and butter'. The children, with the exception of Anne, would then return to their father's study for lessons. The interval between morning lessons and the lunch hour was spent by the girls with Sarah, who taught them the rudiments of sewing. Lunch was usually a simple meal of roast or boiled meat and potatoes followed by sweets such as bread and rice puddings, custards and 'other preparations of eggs and milk, slightly sweetened'. In the afternoons, while their father's time was taken up with parish business, the children, accompanied by Sarah, would walk on the moors. On their return they would take tea in the kitchen, Mr Brontë taking his meal later in the study. After tea he gave his children 'oral lessons in history, biography or travel' while the girls worked at their sewing. While their mother was still alive the children would say their evening prayers at her bedside before seeking their own 'warm, clean beds'.

　　Aunt Branwell, Mrs Brontë's elder sister, made her home with the Brontë family and instilled a keen sense of order and routine into their lives. Mrs Gaskell claimed that 'people in Haworth have assured me that, according to the hour of day – nay, the very minute – could they have told what the inhabitants of the Parsonage were about'. Life at the Parsonage changed very little throughout the years, and in 1832, after Charlotte returned from Roe Head School, she wrote to her new friend Ellen Nussey:

> You ask me to give you a description of the manner in which I have passed every day since I have left school: this is soon done as an account of one day is an account of all. In the morning from nine o'clock till half past twelve I instruct my sisters & draw, then we walk till dinner after dinner I sew till tea-time, and after tea I either read, write, do a little fancy work or draw, as I please. Thus in one delightful, though somewhat monotonous course my life is passed.

Charlotte's conventional account makes no mention of the fantasy worlds which absorbed the Brontës. The events which the Brontës chronicled in their fictional worlds were just as real to them as the quiet, domestic routine of the Parsonage. They all spent periods of time away from Haworth, but it was at home together that their creative lives flourished, close to the wild moorland landscape that was such a great source of inspiration to them.

Layout of the House

When the Brontës moved into the Parsonage, the room to the right of the entrance hall became Mr Brontë's study, sparsely furnished but housing a well-thumbed library and

with walls covered in black-and-white engravings of works by John Martin. Here Mr Brontë carried out parish business and took many of his meals alone. During his time at Haworth he did a great deal of good: writing testimonials and letters to the newspapers on behalf of his parishioners, founding the Sunday school opposite the Parsonage and campaigning for health improvements. In old age he was described as sitting here 'in a plain, uncushioned chair, upright as a soldier' before the fire. It was also in this room that he gave his children lessons, and was later to tell Elizabeth Gaskell, 'I frequently thought I discovered signs of rising talent which I had seldom, or never before, seen in any of their age.' With this conviction, he encouraged all his children in their eager pursuit of knowledge. He was an inspiring father who passed on his love of the arts to his children.

The room across the hall served as both dining-room and sitting-room and was furnished with 'hair-seated chairs and mahogany tables'. Coming from a more affluent background, Ellen Nussey found the Parsonage rooms 'scant and bare indeed'. She recalled how Mr Brontë's fear of fire meant that 'the interior lacked drapery of all kinds' and how 'they never had these accessories to comfort and appearance till long after Charlotte was the only inmate of the family sitting-room'. After the deaths of her sisters, Charlotte took some pleasure in making the Parsonage more comfortable. Clearly many comforts were introduced at this period, for the sale of the Parsonage contents, held after Mr Brontë's death in 1861, included 'Damask and Muslin Window Hangings', 'Stairs Carpets and Rods' and 'Kidderminster Carpets and Rugs'. Unlike his predecessors, Patrick Brontë had no independent income and it appears that few improvements were carried out at the Parsonage during his occupancy. The income from her writing allowed Charlotte to refurbish the rooms she herself used – the dining-room and main bedroom above. The house was re-roofed in 1850 and it appears to have been at this time that the dining-room was extended into the entrance hall and the main bedroom above was enlarged at the expense of the children's study.

Elizabeth Gaskell was the only Brontë biographer to have visited the Parsonage during the lifetimes of Charlotte and Patrick Brontë. She paid her first visit in 1853 when, apart from the two servants, they lived there alone. One of the servants, Martha Brown, told Elizabeth Gaskell of the sisters' nightly habit of walking around the dining-room table, discussing their plans and projects into the night. After Emily's death Charlotte and Anne continued the ritual, and now Martha's heart ached to 'hear Miss Brontë walking, walking, on alone'.

Despite Charlotte's attempts at gentrification, Gaskell noted how 'everything fits into, and is in harmony with, the idea of a country parsonage, possessed by people of very moderate means'. Mrs Gaskell recorded that the dining-room had 'evidently been refurbished within the last few years', and that the 'prevailing colour of the room is crimson, to make a warm setting for the cold grey landscape without'. Curtains had also been introduced to soften the cold grey outlook. In a letter of December 1851, Charlotte writes, 'We have got curtains of union cloth for the dining-room – I ordered them at the factory to be dyed crimson & drab – but they are badly dyed of dull colours and do not please me.'

The room behind the dining-room was described by Mrs Gaskell as 'a sort of flagged store room', which was later converted into a study for Charlotte's husband-to-be.

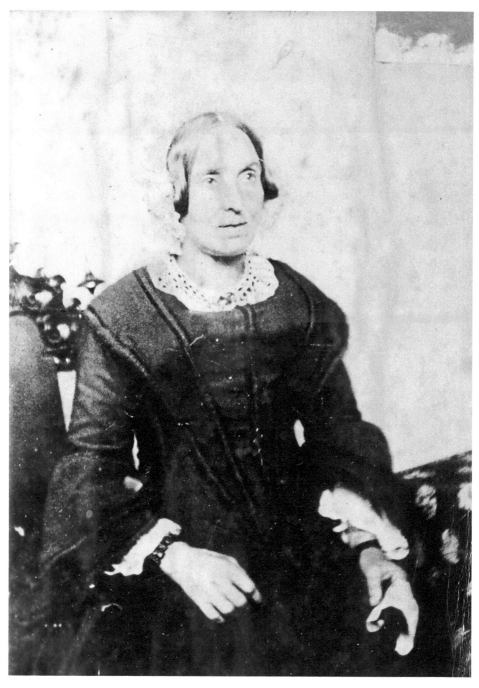

Nancy Garrs (1803–86) joined the Brontë household as a nursemaid in 1816, but was later promoted to cook and assistant housekeeper. After leaving the Parsonage she continued to live in the Bradford area, attending the funerals of both Charlotte and Mr Brontë, and died in the Bradford Workhouse at the age of eighty-three.

In a letter written in 1854, Charlotte describes her preparations for the conversion: 'I have been very busy stitching,' she writes, 'the new little room is got into order now and the green and white curtains are up – they exactly suit the papering – and look neat and clean enough.' A sample of the paper Charlotte used in this room ended up in the New York Public Library, authenticated by Elizabeth Gaskell.

The stone-flagged kitchen was behind Mr Brontë's study. A detailed plan of Haworth dating from 1853 shows a back kitchen to the Parsonage, containing a stone sink and pump, where much of the heavier household work would have been carried out. This back kitchen, with its tall clay chimney, is visible on early photographs of the Parsonage but it is not known for certain when it was built. The kitchen would have been the warm heart of the household but it was also the room most affected by alterations to the house made by Mr Brontë's successor in the late 1870s. The back kitchen was demolished to make way for a large new kitchen extension, and the mullioned window, looking out over the backyard with the moors beyond, was lost in the process. The small vaulted cellar beneath the kitchen offered further storage and a wonderful space for the Brontë children to enact the events taking place in their imaginary worlds.

The five bedrooms were occupied by different members of the family depending on who was living at home at the time. After Mrs Brontë's death, her husband moved into the bedroom across the landing and the main bedroom, above the dining-room, was taken over by Aunt Branwell, and it was here she instructed her nieces in the arts of sewing and household management. Following her death in 1842 the room was used mainly by Charlotte and the occasional guest. It was here that Mrs Gaskell stayed on her visit to the house in September 1853: 'My room was above this parlour, and looking on the same view, which was really beautiful in certain lights, moon-light especially.' The small room squeezed in between the two front bedrooms, known as 'the children's study' in the Brontës' time, served as a nursery in the early days and later became Emily's room. Her diary paper for 1845 includes a sketch she made of herself seated here, with her portable writing desk on her lap. Her dog Keeper lies at her feet and another dog is curled up on the bed. Of the remaining rooms, one was allocated to the servants and the other served briefly as Branwell's studio, although for most of the time it was a bedroom occupied by one or more of his sisters.

The first description of the house was provided by Charlotte's school friend, Ellen Nussey. At the time of her first visit to the house in 1833, Ellen recalled that the 'hall floor and stairs were done with sand stone', and that there was 'not much carpet anywhere except in the sitting-room, and on the centre of the study floor'. She describes the walls as 'not papered but coloured in a pretty dove-coloured tint', although it could well have been the entrance hall and staircase she had in mind, for wall paper was certainly used in the dining-room at an early date. A sample of wallpaper in muted shades of pink and grey was used by Charlotte as the cover of a little book she wrote in the late 1820s.

Its exposed situation and stone floors and passages make the Parsonage a cold house. A mixture of coal and peat was burnt for heat, and Elizabeth Gaskell recalled how fires burning in the grates made a 'pretty warm dancing light all over the house'.

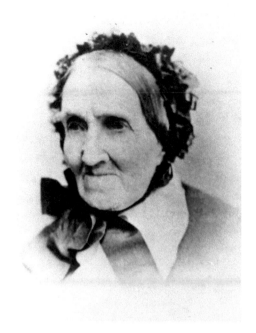

Sarah Garrs (c.1806–99) was taken on as
a nursemaid at the time of Emily's birth in
1818. She eventually emigrated to America
with her husband, William Newsome, and
their children, living in Ohio and Iowa.

Lighting was provided by candles and oil lamps (the 1861 bill of sale mentions a
'Solar Lamp in Bronze').

Sanitary arrangements at the Parsonage were relatively primitive. The privy in the
backyard remained in use (with seats for both adult and child). In this respect the
Brontës fared better than many of their neighbours; the village was served by only
a small number of privies, in some instances only one to a dozen households. The
1861 sale also included two night commodes among the Brontës' household effects.
The Parsonage was one of only five houses in Haworth to have a private well. Mr
Brontë noted in his account book that in 1847 the well was cleaned for the first time
in twenty years and that eight decomposing tin cans, which had tinged the water
yellow, were removed. All water for washing would have been pumped from the
well and then heated in the fireside boiler in the kitchen range. Cans of hot water for
washing would be carried to the bedrooms, where washstands with a ewer and basin
were provided for the occupants' use. Clothing and household linen were washed in
tubs in the back kitchen, and the sisters often shared the hard work of putting the
wet washing through a mangle and doing the ironing. The Parsonage was always
kept scrupulously clean, a fact observed by most of the visitors to the house.

The earliest surviving accounts of life at the Parsonage written by Charlotte date
from 1829. By this time Mrs Brontë and her two eldest daughters were dead and Aunt
Elizabeth Branwell had stayed on at the Parsonage to look after the remaining children.
The two Garrs sisters had been replaced by Tabitha Aykroyd, always known as 'Tabby',
a Haworth woman in her fifties who was to play an important part in the Brontës' lives

for many years to come. Charlotte was beginning to chronicle the fantasy world she was developing with her brother Branwell. *The History of the Year*, dated 12 March 1829, records the origins of their stories and sets the scene as Charlotte writes:

> While I write this I am in the kitchin of the Parsonage house Hawarth [*sic*] Taby the servent is washing up after Breakfast and Anne my youngest Sister (Maria was my eldest) is kneeling on a chair looking at some cakes whiche Tabby has been Baking for us. Emily is in the parlour brushing it papa and Branwell are gone to Keighly Aunt is up stairs in her room and I am sitting by the table writing this in the kitchen.

Charlotte's accounts, and the series of diary papers written by Emily and Anne, are remarkable for the way in which the sisters slip between the worlds of their imagination and the real events taking place around them at the Parsonage: 'The Gondals are discovering the interior of Gaaldine Sally mosley is washing in the back Kitchin,' writes Emily in 1834.

The Brontë Servants

Tabitha Aykroyd

The kitchen was Tabby's domain, and the Brontë children would gather here on winter evenings to listen to her tales of days gone by. There are no surviving portraits of Tabby, and it's almost as if her life didn't begin until she walked through the door of Haworth Parsonage. According to Mrs Richard Briggs, an old Haworth resident, she was known in the village as 'Old Tabby Brontë', and that ' her sister married a man called Wood'. This is Susannah Wood, with whom Tabby briefly shared a home on Lodge Street after fracturing her leg in a fall, and with whom she is buried. Baptism records for Tabby and Susannah have not been located, but records of a third sister, Rose, still survive. Rose was baptised at Haworth on 11 April 1757, the daughter of John Akeroyd, a woolcomber living at Haworth Hall. He married Sarah Sutcliffe in 1757 and a trawl through the Haworth registers reveals three more possible siblings: George, baptised on 28 March 1761; John, who was baptised on 30 January 1763 and Mary, baptised on 25 December 1764. Rose married John Bower of Bingley; George, a woolcomber, died at Haworth in 1839 and shares a grave with Tabby and Susannah; John married Rebekah Dawson in 1786, with Rose's husband John acting as witness, and Mary married William Earnshaw in 1792. Rose's grandson remembered travelling to Haworth with his father on visits to 'Aunt Tabby' at the Parsonage and being given some of Branwell's outgrown shirts. With a network of family in the area, Tabby had many tales to tell. Tabby died on 17 February 1855, aged eighty-four. Charlotte herself was ill at this time and Tabby had been taken to the home of her niece, Mary Ratcliffe, where she could be cared for. She was buried close to the garden wall of the Parsonage and her gravestone records the fact that she was the faithful servant of the Brontë family for over thirty years.

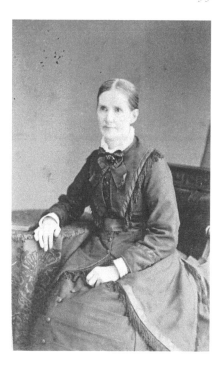

Martha Brown (1828–80), daughter of the Haworth Sexton, John Brown, came to work at the Parsonage at the age of eleven, to assist the elderly Tabitha Aykroyd.

Martha Brown

Martha Brown was one of the six daughters of John Brown, the sexton of Haworth church, who lived in the cottage adjoining the Sunday school. She came to work at the Parsonage to assist Tabby when she was just eleven years old. 'From my first entering the house,' she later claimed, 'I was always recognised and treated as a member of the family.' She remained at the Parsonage until Patrick Brontë's death in 1861. Mr Brontë left Martha the sum of £30, the equivalent of three times her annual salary, as a 'token of regard for long and faithful services to me and my children'. Martha remained on friendly terms with Charlotte's husband, Arthur Bell Nicholls, corresponding with him and visiting him in Ireland. Nicholls tried to persuade her to make her home there, but apart from a spell living with her married sister Ann Binns, in Saltaire, she remained in Haworth where she died on 19 January 1880, aged fifty-one, and was buried in the churchyard, close to the south wall of the Parsonage garden.

The Brontë Story

The Brontë story is well known but worthy of repetition. Patrick Brontë had been born on 17 March 1777 (St Patrick's Day), in a two-room cabin at Emdale, in the parish of Drumballyroney, in County Down. The family's original name is uncertain and usually appears in surviving records as 'Brunty' or 'Prunty'. Driven by ambition, Patrick set about acquiring the education which would enable him to leave his humble

origins far behind. His hard-won education earned him a place at St John's College, Cambridge, where he enrolled as an undergraduate in 1802. Throughout Patrick's academic career his abilities attracted the attention of several influential sponsors, including William Wilberforce, the anti-slavery campaigner. This important new phase of his life was marked by a change of name; Patrick became Brontë instead of Brunty. It has been suggested that he was emulating his hero Nelson, who had recently been created Duke of Bronte; *bronte* is also the Greek word for thunder, an appropriate choice for a young man at the start of his career.

It seems that Patrick had already decided on a career in the church, and following ordination, he held curacies at Wethersfield in Essex and then Wellington in Shropshire, before moving north to Dewsbury, Hartshead-cum-Clifton and Thornton, near Bradford, ending with his final move to Haworth in 1820. By the time he arrived in Haworth Mr Brontë had married Maria Branwell, daughter of a prosperous Cornish merchant, who was visiting relatives in West Yorkshire when they met. Following a whirlwind courtship, the couple married and their six children were born in quick succession: Maria (1814), Elizabeth (1815), Charlotte (1816), Patrick Branwell (1817), Emily Jane (1818) and Anne (1820).

Following his wife's death shortly after the move to Haworth, Patrick Brontë was faced with the daunting prospect of a sprawling parish to administer and six young children to support and educate. The opening of a new school within travelling distance of Haworth and intended for the daughters of impoverished clergymen must have seemed a perfect solution. The school was at Cowan Bridge, near Kirkby Lonsdale, and the two eldest Brontë girls, Maria and Elizabeth, were sent there in 1824, followed soon after by Charlotte and Emily. The school regime was extremely harsh, and first Maria, then Elizabeth, was sent home with ill health, where they died within a few weeks of each other aged just eleven and ten years. Charlotte and Emily were withdrawn from the school and for the next few years remained at home, sharing Branwell's lessons with their father.

In January 1831 Charlotte, aged fourteen, was sent to Miss Wooler's school at Roe Head, near Mirfield. She worked hard, carrying away a silver medal for achievement when she left the following year. It was at Roe Head that she met her lifelong friends Mary Taylor and Ellen Nussey. She eventually returned to the school as a teacher, taking first Emily then Anne as pupils. Lacking fortune and connections meant that the sisters were unlikely to attract husbands to support them. Careers in the professions were not open to women, and working-class occupations were also out of the question. The only career option which would not incur a loss of social status was teaching, and over the next few years the sisters spent unhappy periods working away from home as governesses.

Great things were expected of Branwell, the only boy. His family believed that he possessed great creative talent and that one day he would carve out a glittering career in either art or literature. Ambition and hard work had enabled his father to rise in the world, and Branwell grew from childhood bearing the weight of his family's expectations. His artistic career began and ended in Bradford, where he spent twelve months as a portrait artist in 1838. After the failure of the Bradford venture Branwell

accepted a post as tutor to the sons of Mr Postlethwaite at Broughton-in-Furness, Cumbria. For a while he made a success of his post and also managed to write in his spare time, but he was eventually dismissed, allegedly for being 'the worse for drink'. His next employment was as assistant clerk-in-charge at Sowerby Bridge railway station on the outskirts of Halifax. It was not the career his family had hoped for, but to Branwell it was a new and exciting world. Six months later he was promoted further up the line at Luddenden Foot. A railway audit of the ledgers revealed a discrepancy in the accounts, and although Branwell was not suspected of theft, he was held responsible for negligence.

In the 1840s Branwell achieved a measure of success when several of his poems appeared in local newspapers, making him the first of the Brontë siblings to see his work in print. Eventually, after his string of failed careers, he became tutor in the Robinson household at Thorp Green Hall near York, where Anne was employed as a governess. Anne decided to leave Thorp Green and returned to Haworth in June 1845, followed shortly after by Branwell, once again dismissed in disgrace for 'proceedings bad beyond expression'. It is alleged that he had embarked on an affair with his employer's wife, Mrs Robinson. Mrs Robinson was widowed shortly after, but when it became clear that she had no intention of marrying him, Branwell turned to drink and drugs, and although he did make further attempts to gain employment, he never worked again.

In an attempt to escape the dreary lives of governesses, the sisters decided to set up a school of their own at the Parsonage. Charlotte decided that before they put their plan into action, she and Emily should spend time at a school on the Continent. In February 1842, supported by their aunt's money, Charlotte and Emily travelled to Brussels to study at the Pensionnat Heger, a well-respected girls' school. Although the reason Charlotte gave her aunt for wishing to go abroad was to improve their language skills and enhance the appeal of their school, the full truth seems to be that she had been tempted by descriptions of Brussels in the letters of her friend Mary Taylor, who was already studying there, and longed to spread her wings. The directress of the school was Madame Zoë Claire Heger, and her husband, Constantin, who taught French literature to the girls, soon became aware of the Brontës' outstanding abilities. Heger's influence on Emily is difficult to assess, but his lessons were fundamental to Charlotte's emergence as a great writer.

The sisters remained in Brussels until October, when they were recalled by news from home of their aunt's death. M. Heger wrote to Mr Brontë expressing his regret at losing such exceptional pupils, and while Emily decided to remain at the Parsonage as housekeeper, Charlotte returned to Brussels as a student-teacher. She felt increasingly isolated at the school without Emily's company, and her strong feelings for Heger developed into an obsession. On her return to Haworth in January 1844, Charlotte confided to Ellen Nussey, 'I suffered much before I left Brussels. I think, however long I live, I shall not forget what the parting with M. Heger cost me.' She hoped to combat her unhappiness through hard work, but the school project foundered after a prospectus was circulated and pupils could not be found.

In the autumn of 1845, the Brontë sisters found themselves unemployed and together at the Parsonage. When Charlotte discovered a notebook containing

Emily's poems she was struck by their quality. 'Something more than surprise seized me,' she later wrote, 'a deep conviction that these were not common effusions, nor at all like the poetry women generally write. I thought them condensed and terse, vigorous and genuine. To my ear, they had also a peculiar music – wild, melancholy and elevating.' Anne had also written poetry, and Charlotte found that 'these verses too had a sweet pathos of their own'. She immediately hatched a plan to publish a selection of poems by all three sisters.

Emily was furious at the invasion of her privacy but was eventually won round to the idea of publication. Branwell was not included in the project despite the fact that he had already had several of his poems published in local newspapers. Charlotte later claimed that he never knew of his sisters' publications and was never told, for fear of causing him 'too deep a pang of remorse for his own time misspent, and talents misapplied'. The sisters used a legacy from Aunt Branwell to finance publication and *Poems*, published under the pseudonyms Currer, Ellis and Acton Bell, appeared in 1846. Despite some favourable reviews, only two copies of the book were sold. *Poems* by Currer, Ellis and Acton Bell must rank amongst the greatest failures in the history of publishing, but the sisters failed to be crushed, and each set to work on writing a novel.

The first Brontë novels were published in 1847 following many years of literary activity beginning in childhood. Once again the sisters concealed their true identities, publishing under their pseudonyms Currer, Ellis and Acton Bell. Charlotte's first attempt to write a novel for publication was *The Professor*. It was rejected by every publisher to whom she sent it, although the London firm of Smith, Elder & Co. recognised the author's potential and sent a letter to her which 'discussed its merits and demerits so courteously that this very refusal cheered the author better than a vulgarly expressed acceptance would have done'. They added that any future work would 'meet with careful attention'. Charlotte was already working on another novel which was dispatched to the firm a few weeks later. *Jane Eyre* appeared in October 1847 and was instantly popular with the reading public.

Emily's *Wuthering Heights* and Anne's *Agnes Grey* had already been accepted for publication by Thomas Cautley Newby. It was agreed that the authors would pay the sum of £50 which Newby undertook to refund when a sufficient number of copies had sold. The two novels were published together as a three-volume set in December 1847. The phenomenal success of *Jane Eyre* aroused a great deal of speculation over the identity of its author, Currer Bell, which was fuelled by the appearance of further 'Bell' novels.

Wuthering Heights and Anne's second novel, *The Tenant of Wildfell Hall*, were considered 'coarse'; 'lady-readers' were warned against them. An anonymous reviewer for *Paterson's Magazine* advised readers to 'read *Jane Eyre* … but burn *Wuthering Heights*'. Reviews of *Jane Eyre*, which had been favourable at first, began to reflect the shocked condemnation levelled at the works of Ellis and Acton. The works of all three authors were seen as flawed in their depiction of wild characters and violent scenes, although reviewers were forced to acknowledge the power and originality of the Bells' writing, and the books continued to sell.

Branwell died suddenly on 24 September 1848, aged thirty-one. Soon after, Emily and Anne became ill. In fact both sisters were dying from tuberculosis, and after Branwell's funeral, Emily never left the Parsonage again. She died on 19 December 1848, at the age of thirty. Anne was anxious to try a sea cure, and on 24 May 1849, accompanied by Charlotte and Ellen Nussey, she set out for Scarborough, where she died just four days later at the age of twenty-nine. To spare her father the anguish of another family funeral, Charlotte had her sister buried in Scarborough, then returned to Haworth alone.

Charlotte outlived her sisters by six years and produced two further novels: *Shirley*, published in 1849, and *Villette*, published in 1853. *The Professor* was finally published in 1857, two years after Charlotte's death. In 1854 Charlotte accepted a proposal from her father's curate, Arthur Bell Nicholls, and the couple were married in Haworth Church on 29 June 1854. The marriage was happy, although short-lived. Charlotte Brontë died on 31 March 1855, in the early stages of pregnancy. Mr Brontë lived on at the Parsonage for the remaining six years of his life, cared for by his son-in-law. In a letter written to the Right Reverend Lord Bishop of Ripon, Patrick Brontë wrote, 'I have lived long enough to bury a beloved wife, and six children – all that I had – I greatly enjoyed their conversation and company, and many of them were well fitted for being companions to the wisest and best – now they are all gone – their image and memory remain, and meet me at every turn – but they themselves have left me, a bereaved old man.'

Tourism Comes to Haworth

In the aftermath of Charlotte's death, speculative obituary notices began to appear in the press, and acting on a suggestion made by Ellen Nussey, Mr Brontë requested Elizabeth Gaskell to write an authorised account of his daughter's life. Mr Nicholls was unenthusiastic about the proposed biography and dreaded having his private life made public but complied with Mr Brontë's wishes. *The Life of Charlotte Brontë* was published in March 1857, just two years after Charlotte's death. The Brontës' novels had created a storm on publication, and the story of their authors' lives is as compelling as the fiction. The biography generated a great deal of interest in the Brontës' lives, and Patrick Brontë, who took a great pride in his children's achievements, lived long enough to witness his home at Haworth become a destination for literary pilgrimage. A trickle of visitors had started to arrive in Charlotte's lifetime, and in a letter dated 5 March 1850 she had written, 'Various folks are beginning to come boring to Haworth on the wise errand of seeing the scenery described in *Jane Eyre* and *Shirley*.' Charlotte had found the situation slightly ridiculous, especially as neither of the novels had a Haworth setting. As early as 1851 trade directories for Haworth were stating that 'the far-famed and highly-gifted authoress of *Jane Eyre* &c. resides here. She is the daughter of the incumbent, the Revd Patrick Brontë, BA.' Mr Brontë would often receive curious visitors at the Parsonage when the mood took him, and would cut Charlotte's letters

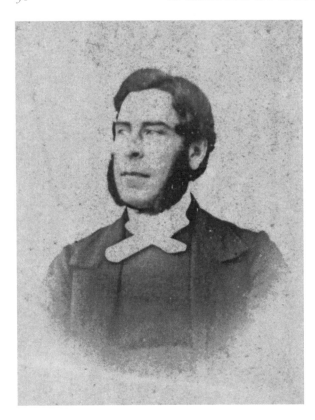

Photograph of Charlotte Brontë's husband, Arthur Bell Nicholls (1818–1906), possibly taken at the time of their marriage in 1854.

into snippets to satisfy the many requests for samples of her handwriting that came from admirers of her books.

One such visitor was John Elliot Cairnes, who visited Haworth in 1858 after reading Mrs Gaskell's biography.

> It occurred to me that it might not be amiss if I paid my respects to the old gentleman; – and, on being told by the sexton, in answer to my inquiry, that this had been done by some others who had been well received, I sent in my card. I was informed that Mr Brontë had, a few hours previously, retired to bed, not feeling well, but that he hoped I would walk in and see the house. This I, of course, did under the guidance of the maid, Martha (mentioned by Mrs Gaskell). She is an interesting looking girl with very dark eyes and hair, and would be pretty but for the loss of nearly all her front teeth. She shewed me first the parlour with Charlotte's portrait on the dark side of the room, fronting a medallion cast of Branwell on the other, while on either side of the door, there was the Duke of Wellington and Thackeray. There was also her little library, not above sixty or seventy volumes in all, but a most choice collection.

One of the last glimpses we have of Patrick Brontë is provided by Meta Gaskell, who accompanied her mother on a visit to Haworth Parsonage in late October 1860:

We were taken into his bedroom; where everything was delicately clean and white, and there he was sitting propped up in bed with a clean nightgown, with a clean towel laid just for his hands to play upon – looking Oh! very different from the stiff scarred face above the white walls of cravat in the photograph – he had a short soft white growth of beard on his chin; and such a gentle, quiet, sweet, half-pitiful expression on his mouth, a good deal of soft white hair, and spectacles on.

Patrick Brontë shook hands with his visitors and Meta records that they discussed various topics before Mrs Gaskell 'said something about our not staying too long to tire him and that we were going, for me to make a sketch', to which Mr Brontë replied,

'There are certain circumstances, you see,' looking very knowing, 'which make it desirable that when you leave in five minutes or so, we should shake hands – and I give your daughter free leave to make a sketch, or do anything outside the house. Do you understand Latin? Mrs Gaskell does at any rate, well, *verbum sap*, a word to the wise,' and then he chuckled very much; the gist of it was, as Mama saw, and I guessed, that he feared Mr Nicholls' return from the school – and we were to be safely out of the house before that.

Early on the morning of 7 June 1861, Patrick Brontë was seized with convulsions and was unconscious before Mr Nicholls could get to him. Watched over by Nicholls and Martha, he died later that afternoon at the age of eighty-four. His death was certified by the Haworth doctor, Amos Ingham, and records his cause of death as 'chronic bronchitis', 'dyspepsia' and 'convulsions'.

Patrick Brontë's funeral was held on 12 June 1861, and was attended by hundreds of his parishioners. The burial service was read by the Vicar of Bradford, Revd Dr Burnett, and according to an obituary in the *Leeds Intelligencer*, Mr Nicholls 'appeared to be deeply affected'. There was a general expectation that Nicholls would succeed Mr Brontë as Perpetual Curate, and be allowed to remain at the Parsonage, but it soon became clear that the Church Trustees had other ideas. The Vicar of Bradford had nominated his own curate, John Wade, and on this occasion, the majority of the trustees supported his choice. Possibly it was felt that the time had come to break with Brontë associations, but the fact that Wade was a man of independent means counted in his favour. The Parsonage was in need of repair and Wade would be able to foot the bill as well as contribute to parish funds.

On 1 and 2 October 1861, the furniture and household contents of Haworth Parsonage were sold at auction. Taking many of the personal effects of his wife and her family, Nicholls returned to his native Ireland, where he lived at The Hill House, Banagher, becoming a farmer and eventually marrying his cousin Mary Bell. Arthur Bell Nicholls died in 1906 at the age of eighty-eight, having survived Charlotte Brontë by more than fifty years.

715

Haworth Parsonage.

Mr. CRAGG has the honor to announce that he has received instructions to SELL BY AUCTION, on Tuesday, 1st October, 1861, at the Parsonage, Haworth, the valuable household FURNITURE, of the late Rev. Patrick Bronte, B A.,

Comprising Eight Mahogany Chairs in Hair, Six ditto in ditto, Two Mahogany Card Tables, Mahogany Dining Table, Mahogany Poll Screen, Mahogany Rocking Chair in Hair, Kidderminster Carpets and Rugs, Stairs Carpets and Rods, Damask and Muslin Window Hangings, Three Engravings in Frames, by Martin, viz.--" The Deluge," " Belshazzars's Feast," and "Joshua commanding the Sun to stand," Three other Engravings and Frames, viz.--" St. Paul preaching at Athens," " The Resurrection announced to the Apostles," and " The Passage of the Red Sea," Two Oil Paintings in Frames, viz.--" Bolton Abbey," and "Kirkstall Abbey;" square Mahogany Pembroke Table, Mahogany Side Tables, Mahogany Work Table, large Chimney Glass in Mahogany Frame, Mahogany Sofa in Hair, Clock in Oak Case, Camp Bedstead with Mattrasses, Beds, Bolsters and Pillows, Washstands and Appendages, Dressing Tables and Toilet Glasses, 12 Bed-room Chairs, Chest Painted Drawers Painted Wardrobe, Bronze Tea Urn, Painted Cupboard, Painted Bookcase and Drawers, Two Night Commodes, Painted Kitchen Cupboard, Painted Kitchen Table, Three Polished Birch Chairs, Birch Rocking Chair, Copper Kettle, Bread Fleak, Warming Pan, Two pairs Bellows, Four Tea Trays, Wringing Machine, Tins, Pans, Crockery, Six Water Bottles, Three Cut Decanters, Glass Pitcher, Deal Table, Three Flour Jars, Japanned Coal Box, Fender and Fire Irons, Solar Lamp in Bronze, Delf Case, and about 200 vols. of BOOKS.

The lots being numerous, the Sale will commence at ELEVEN o'clock in the forenoon. On view, on Monday, Sep. 30th.

Bill of Sale, on death of Rev. Bronte, father of Charlotte Bronte —

The 1861 bill of sale for Haworth Parsonage. After Mr Brontë's death the family's furniture and the Parsonage contents were sold at auction.

Three

John Wade:
1861—1898

The present rector of the parish has been much abused for his action in getting the old church destroyed … Why could not the old church have been left and a new one built on another site? That he was bored by the crowds of visitors who poured into the rectory garden, and even wormed their way into his private sanctum, we have no doubt, but he might have adopted the easy method of allowing visitors to look round one day a week, and have been solaced by the thought that he was giving pleasure to thousands of worthy people.

J. A. Erskine Stuart, *The Brontë Country: Its Topography, Antiquities, and History*, 1888.

Charles Hale was one of many Americans inspired to visit Haworth after reading Mrs Gaskell's biography of Charlotte Brontë. He arrived in the village shortly after Mr Brontë's death in 1861 when the Parsonage was being fitted out in preparation for his successor, and reported in a letter that

> here a great transformation is going on. The house is a hundred years old and is sadly out of repair, for Mr Brontë disliked to have mechanical work going on there. Only once, from absolute necessity, to keep out bad leakage, he allowed the roof to be mended. The new incumbent does not choose to go into a rotten old house, but they are doing very much more than making merely necessary repairs. They are putting in fireplaces and mantlepieces of marble, and windows of plate glass, a single pane filling the whole sash and weighing thirty pounds. The stone walls, stone floors of the passages and stone staircases will stand unchanged for another hundred years as they have the last – but the masonry is new pointed and the house will be refitted anew throughout.

John Wade, the new incumbent, moved into Haworth Parsonage shortly after Hale's visit, along with his younger sister, Emma. Hale describes Wade as 'very much liked'

in Haworth, but right from the first he gained a reputation for antipathy to the Brontë cult and regularly refused visitors admission to the Parsonage. It's difficult not to have some sympathy for Wade. Despite Charlotte's gentrification of the Parsonage in 1850, it seems that the house was generally in a poor state of repair, and in carrying out his alterations to the house, Wade enraged many Brontë enthusiasts. His improvements were noted with disgust by W. H. Cooke, who after making the trip to Haworth in 1867, described Wade as a man of 'execrably bad taste' who had refused to allow him access to the Parsonage dining-room where the Brontës had written the books 'which have conferred immortal lustre upon this incumbent's present residence, and which will live long after he himself has mouldered down to dust, and his brand-new window frames have rotted to decay'.

It appears that Ellen Nussey, Charlotte Brontë's close friend, continued to make periodic visits to Haworth. In her reminiscences, which were partly published in *Scribner's Monthly* in 1871, she wrote of the changes at the Parsonage:

> The Parsonage is quite another habitation from the Parsonage of former days. The garden which was nearly all grass and possessing only a few stunted thorns and shrubs, and a few currant bushes which Emily and Anne treasured as their bit of fruit garden, is now a perfect arcadia of floral culture & beauty. At first the alteration in spite of its improvement strikes one with heart-ache & regret, for it is quite impossible even in imagination to people those beautified rooms with their former inhabitants...

John Wade was born in Bradford in 1832, the son of William Wade, a carrier, and his wife Elizabeth, who were living in the Horton area. By the 1851 census Wade was listed as a 'railway clerk', living at 11 King Street in the Horton district with his widowed mother and sister, who worked as a milliner's apprentice. By 1859 Wade had made a remarkable transition from railway clerk to Oxford graduate and become curate of Bradford parish church. Emma appears to have been no longer working, and the two of them were living at 39 Hill Side Villas in Bradford, before Wade's appointment as Perpetual Curate at Haworth in 1861.

On 30 April 1862, the year after his appointment, Wade married Sarah Wright at Bradford Cathedral. Sarah was the daughter of James Wright, a spirit merchant, and had been born at Saddleworth, but at the time of her marriage was living in Horton, Bradford. Over the next eight years, John and Sarah had four children: Emily Frances, born on 15 April 1863; Charles Edward, born on 25 July 1864; George Herbert, born on 14 August 1868 and William Reginald, born on 2 April 1870. The family were assisted by Elizabeth Garratt, a twenty-year-old maid who had been born in Derby, and Jane Thomas, an eighteen-year-old nursery maid from Haworth. Jane had been born in 1852, the eldest of the ten children of James Thomas and his wife Elizabeth. She had a slight connection with the Brontës in that her father was the cousin of William Thomas, who had his portrait painted by Branwell. Emily Dowson, an admirer of the Brontës who visited Haworth in 1866, had to be content to glimpse the Parsonage from the gate, but she did get an opportunity to speak to the servants: 'one

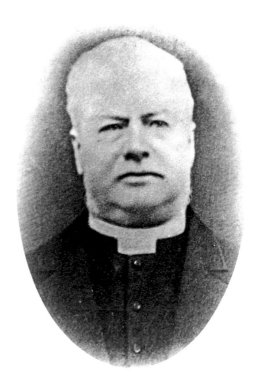

The Reverend John Wade, who became
Perpetual Curate at Haworth in 1861,
following the death of Patrick Brontë.

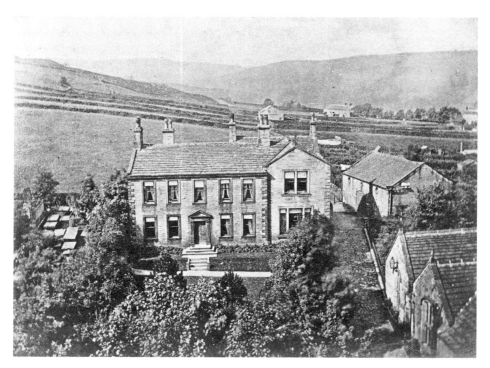

Photograph of the Parsonage showing the barn which was demolished in 1903.

a merry Yorkshire lass who shuddered as she spoke of the wintry weather, and the other a weird cadaverous woman who had known the Brontës and been in Charlotte's class at the Sunday school'. Maybe the 'merry Yorkshire lass' was Jane Thomas.

In 1864 the Haworth chapelry was finally separated from the parish of Bradford and John Wade became the first Rector of Haworth. Around this time Wade purchased property in the vicinity of the church and Parsonage. A group of unsightly buildings, consisting of a butcher's shop and cottage, back kitchen, stable and privy, standing close to the north side of the church and blocking the windows, were purchased and demolished in 1866. Wade also purchased cottages just below the Parsonage in Church Street. Two of these were rented out to Anne Feather and William Toothill, while a third, standing at the north-east corner of the church, was demolished in 1870 in order that Church Street could be re-routed slightly further north and the churchyard widened so that the church boiler house, which had previously projected into the street, could be brought within the curtilage of the church. Wade was keen to improve the appearance of the church and also carry out the many repairs that were needed, for it was not only the Parsonage that had fallen into a poor state of repair.

Over the years the Wade family continued to grow: Katherine Beatrice was born on 16 November 1871; Eleanor Mary on 6 July 1873; Elizabeth Winifred on 31 December 1874 and Lilian Blanche on 16 September 1876. This last daughter, Lilian, died early in the following year. Emma was no longer living with the family (in 1901 she was living on her own means in the Heaton district of Bradford, where she died in 1908, aged seventy-four) but this still left John and Sarah with seven children and usually two servants (at the time of the 1881 census they were served by Mary Jane Metcalfe, who worked as cook, and Grace Brooke, a housemaid). The Parsonage was far too small to accommodate them all, and in 1872 plans were drawn up by the Bradford-based architectural firm of Milnes & France to extend the house. According to the Brontë biographer Marian Harland, Wade is said to have proposed the purchase of the house by Brontë enthusiasts, which would have enabled a new parsonage to be erected elsewhere in the village. The proposal met with no response at that time, and eventually Wade had little option but to enlarge the house. In the late 1870s a two-storey gabled wing was added to the north of the Parsonage to provide a large dining-room on the ground floor with two good-sized bedrooms and bathrooms above. Access to the new upper rooms was created by adding a flight of stairs leading off to the right from the half-landing. These stairs have since been removed although one still remains in the recess which now houses the Brontës' long-case clock. The original cellar was extended beneath the new wing to provide a large wash kitchen with a fireplace and set pot, as well as additional storage. The Brontës' back kitchen was demolished to make way for a large kitchen extension at the rear of the house, and the former kitchen became a passageway through to the new dining-room. Although obviously an addition, the new wing was designed with care, taking into account the style and materials used in the original building.

Inevitably there was a shocked reaction to Wade's alterations to the Parsonage, but this was as nothing compared to the storm he created over the demolition of the old church. The old church was in a poor state of repair, and Michael Merrall, a Haworth

textile manufacturer, offered to put up the money for a new building. Although the old church may not have been considered important in architectural terms – Mrs Gaskell describes the interior as 'common-place: neither old enough nor modern enough to compel notice' – its association with both Grimshaw and the Brontës meant that there was a great deal of opposition to its proposed demolition – most of it coming from outside Haworth. Various alternatives were considered before eventually being rejected, and with the exception of the tower, the old church was demolished in 1879 and rebuilt on the same site. The new building, described as 'ready-made Gothic', was consecrated in 1881. A reredos depicting Leonardo da Vinci's *The Last Supper*, made of Derbyshire alabaster, was presented to the new church by Mrs Wade.

Visitors continued to arrive in Haworth, many of them having read Mrs Gaskell's biography of Charlotte Brontë, which also created a market for relics of the famous family. One of the largest collections of Brontë material remained in Haworth and belonged to Martha Brown, the Brontës' faithful servant, who died on 19 January 1880. Her large collection of paintings and drawings by the Brontës, along with many of their personal belongings, passed to her five sisters at her death. These sisters struggled to raise their families on low incomes, and, when sought out by collectors, often sold the items inherited from Martha. Ann Binns, the eldest of Martha's sisters, was widowed in 1886 and forced to sell her large collection of Brontë items. Amongst the principal purchasers at the sale were Francis and Robinson Brown, cousins of the Brown sisters, who went on to open Haworth's first museum of Brontë relics above their refreshment rooms at the top of Haworth Main Street. The venture was not a success: the demolition of the old church had meant a reduction in the number of visitors and led to the ultimate failure of the Brown brothers' enterprise. They removed to Blackpool, taking their collection with them, and it was gradually sold. Martha's sister, Tabitha Ratcliffe, remained in Haworth and was happy to show her collection to interested visitors and even to sell if a sufficient price was offered. This was a period of active collecting of Brontëana, and Haworth became a rich field for collectors. There was a growing sense amongst admirers of the Brontës of the need to gather together and preserve the surviving possessions of the family before the opportunity was lost for ever. In the autumn of 1893 a proposal was made for the foundation of a society to promote the study of the works of the Brontës and collect what remained of their possessions. Shortly before Christmas of that year, a small group of local enthusiasts founded the Brontë Society. The Brontë Society opened their first museum in Haworth in 1895, above the Yorkshire Penny Bank at the top of Main Street.

The opening of the new museum had an impact on visitor figures and by the time John Wade retired in 1898, Haworth was attracting an estimated 7,000 visitors annually. They were rarely allowed to intrude on the privacy of his home, although many visitors made the attempt. Marian Harland was one of the privileged few to be granted access to 'the sacred precincts' of the Parsonage while on a visit to Haworth gathering material for her book, *Charlotte Brontë at Home* (1899):

> We were taken, first, into the room at the right of the entrance, once Mr Brontë's study ... It is bright now with sunlight which the windows have been enlarged

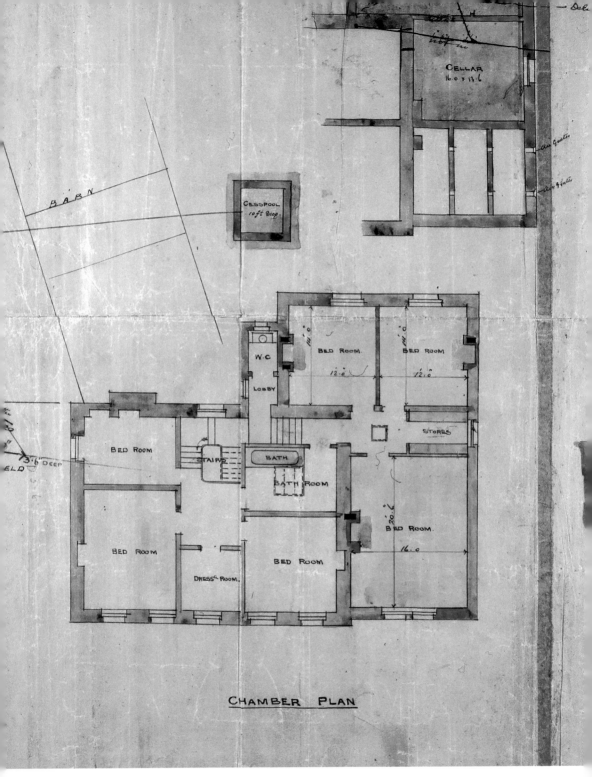

CELLAR
16.0 x 13.6

BARN

CESSPOOL
10 ft Deep

W.C

LOBBY

BED ROOM
12.0

BED ROOM
12.0

STORES

3.6 DEEP
ELD

BED ROOM

STAIRS

BATH

BATH ROOM

BED ROOM
20.6
16.0

BED ROOM

DRESSG ROOM.

BED ROOM

CHAMBER PLAN

Plan of John Wade's alterations to the Parsonage, 1872.

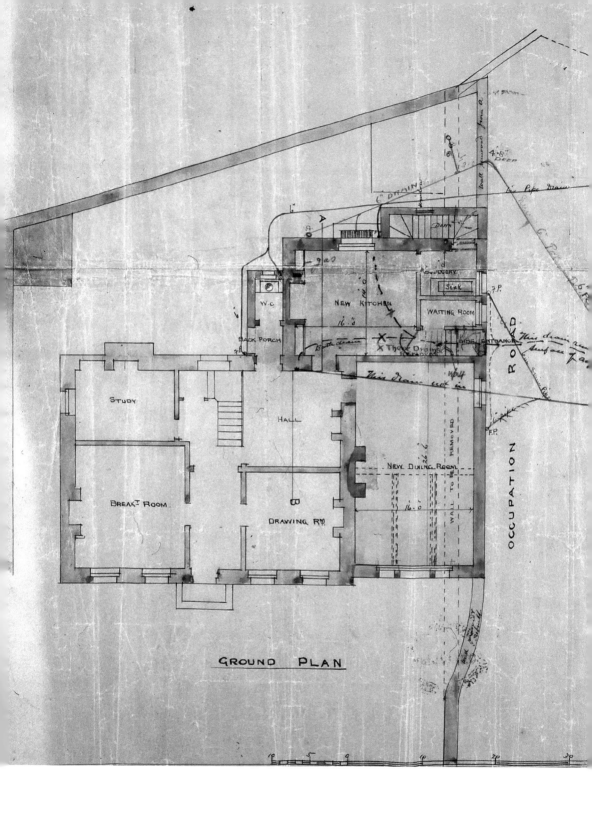

GROUND PLAN

The Brontë Society opened its first museum on the upper floor of the Yorkshire Penny Bank, now the Tourist Information Centre, at the top of Haworth's Main Street. The museum remained here for thirty-three years until the Society's acquisition of the Parsonage in 1928.

to admit, paper of a soft neutral tint conceals the rough walls, books fill the shelves, and pictures are set and hung here and there. It looks like what it is – the workroom of a thoughtful scholar of liberal views and refined tastes ... Across the hall is the room in which ... was the family sitting-room, – the 'parlour', – in which meals were served, and where the sisters wrote, sewed, studied, and received their few visitors. It is of fair size, and, as furnished now, pleasant and cozy ... At a subsequent visit we were admitted to the heart of the Parsonage-home as it now is, – a large, cheery, handsome library-parlour in the wing. At our first call, we saw none of the Rector's family except himself.

Mr Wade's disinclination to receive within the rectory the throng of sight-seers who troop thither from all parts of the world has been the subject of animadversion as virulent as that called forth by the alterations in church and parsonage. When one pauses to reflect that the annual visitation used to be numbered by thousands, and still mounts up into the hundreds, that the Rector is a busy man and a studious, conscientious in the discharge of parochial and domestic duties, and that even a clergyman is supposed to have some of the rights of a private citizen to hold his home as his castle, the present incumbent of Haworth may be less bitterly censured for declining to grant the run of his premises to the curious and the sentimental public.

The 1891 census shows the Wade family dispersing. John and Sarah were living at the Parsonage with Eleanor and Elizabeth. Katherine was away on a visit to Rawdon, near Leeds, accompanied by her brother George, now an Oxford undergraduate. Charles Edward, master of Merchant Taylors' School in London, was on a visit to Haworth. The family were served by a cook, Annie Elizabeth Halliday, and Mary Ann Dickinson, a housemaid. Two years later the Wade family experienced a tragedy. With the exception of Lilian, all of the Wade children survived childhood, but on 13 April 1893, twenty-one-year-old Katherine Beatrice Wade died at the Parsonage. Her death certificate records the cause of her death as 'Muco-enteritis', which according to a list of archaic medical terms, is an 'affection of the intestinal mucous membrane characterised by constipation or diarrhoea, sometimes alternating, colic, and the passing of pseudomembraneous shreds or incomplete casts of the intestine'.

John Wade preached his last sermon at Haworth on 23 January 1898 before retiring to Hanbury, near Macclesfield. The 1901 census shows him living at the Mount, with Sarah, their daughters, Eleanor and Elizabeth, and a servant. He died in September of that same year at the age of sixty-nine and Sarah continued to live at the house with their daughters.

John Wade has frequently been charged with 'desecration' for his involvement in the alterations to the Parsonage and demolition of the old church. He is still remembered as resenting his famous predecessors and attempting to stamp out their image in Haworth. Wade clearly saw his role as promoting Christian worship rather than preserving a shrine to the Brontës, and declared that he 'was called to this parish to conserve the highest interests of the church committed to him, and not to act as the curator of a museum'.

Four

Story, Elson and Hirst: 1898–1928

You will hardly wonder that I can raise no great enthusiasm for the change, especially as we have liked this house and were quite contented to remain here for our time in Haworth.
 Revd J. C. Hirst, letter to Sir James Roberts, 21 May 1928.

Following on from Wade, the Parsonage served as home to three further incumbents: T. W. Story (1898–1919), G. A. Elson (1919–25) and J. C. Hirst (1925–28).

Thomas William Story (1898–1919)

Thomas William Story was born in 1863 at Kingmoor, Carlisle, the son of John Story, a gentleman farmer, and his wife Margaret. His father died when Thomas was young, and he and his mother went to live with his grandfather, George Rayson, at Great Blencow. By the early 1880s Story and his mother were living at the home of his uncle, William Rayson, at Cowley in Oxford. Story gained a BA degree in 1884 and MA degree in 1887. By 1891 he was curate at Dewsbury, lodging in the town with a widow named Mary Bryan. During his time at Dewsbury he met Mary Jane Richardson, the daughter of Joseph Richardson, a manufacturer, and his wife Sarah Elizabeth. The couple were married at Holy Trinity church, Batley Carr, on 27 July 1898, the same year in which Story became Rector of Haworth.

The 1901 census shows that by this date the Storys had been joined at Haworth Parsonage by Mary Jane's mother, now a widow, and there was also a twenty-four-year-old domestic servant, Mary Jane Heath, born in Southport, Lancashire. On 20 June 1902 the first of the couple's two children, Margaret Irene, was born. Their son Charles William Herbert was born on 17 April 1904. With two children to care for, further domestic help was required. Nina Yate Meyer, a twenty-one-year-old

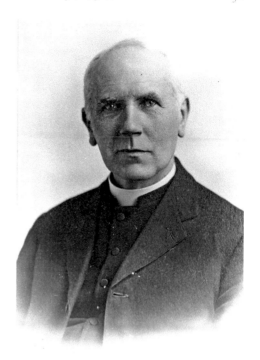

Photograph of Thomas William Story,
Rector of Haworth, 1898–1919.

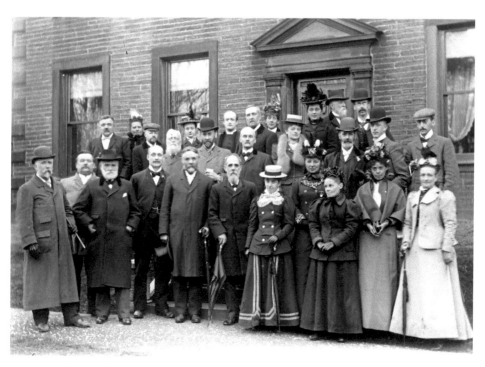

A group of Brontë Society members pictured outside the Parsonage, 1899.

nursery governess, had joined the family by 1911, and Mary Jane Heath had been replaced by seventeen-year-old Emma Stenton.

Story was clearly interested in the history of his home at Haworth. Over the months he published extracts from the Haworth registers in the parish magazine, which in 1909 were collected together and published in book form as *Notes on the Old Haworth Registers*. In his preface to the small volume, Story writes,

> Haworth is no doubt interesting mainly because of its association with the Brontë family, but the writer has been content to give little more than the entries in the registers which refer to them, feeling that he could not add anything new to the extensive Brontë literature.

We know little of how the Parsonage rooms were lived in by these later incumbents, but George Day and P. F. Lee, who were welcomed to the house in the 1890s, recalled that they were given tea in the present rector's study which had formerly been the Brontës' dining-room. The storeroom converted by Charlotte into a study for her husband-to-be was too damp for use by this date.

Story's time in Haworth was marked by the building of a large new Sunday school, completed in 1904, on a plot of land behind the old Sunday school. In its heyday, attendances of 500 were not uncommon, and the building provided a venue for many social activities. By the 1960s the building was found to be riddled with dry rot and was demolished. Story is remembered as being popular with his younger parishioners, despite the fact that he was a strict disciplinarian. Towards the end of his time in Haworth he upset many of the older residents by encouraging the young men to enlist.

Thomas Story died on 20 November 1939 at the age of seventy-seven. He was buried in the moorland cemetery at Haworth, where his mother Margaret was already buried (she had died on 13 March 1916, aged eighty-nine). Eventually Story's wife, Mary Jane, who died on 31 January 1952 aged eighty-four, was also buried there. The Storys' daughter, Margaret Irene Forsythe, who had married relatively late in life, died in 1981. Charles Herbert followed his father into holy orders and died in 1989.

A brief obituary of T. W. Story, which appeared in the Haworth parish magazine, states that

> we have always felt that he belonged to us: certainly it was here that he spent the best years of his life. He was a man with many interests, and I gather that he did a great pastoral work here at the beginning of the century. Not least, he sought to rouse enthusiasm for the past history of the village, and his *Notes on the Haworth Registers* are full of interest.

George Alfred Elson (1919–25)

George Alfred Elson was born in 1874 at Holborn, London, and baptised on 29 March at St Barnabas's in Finsbury. His parents were William and Mary Ann Elson.

Church Street and the side entrance to the Parsonage, *c.* 1900.

The new Sunday school was built in 1904 during Story's time at Haworth and the attendance of 500 children was not uncommon. The building, which stood opposite the Parsonage, was demolished in 1965.

By 1891 William Elson was dead and his widow was living on a private income at 151 Richmond Road, London, with her two sons, Ernest, aged twenty-one, and George Alfred, aged seventeen. Both young men were working as clerks, but by 1899 George Alfred had gained a BA degree at Oxford followed by a master's degree in 1904. Following ordination, Elson took up his first curacy at St Andrew's in Watford, Elstree. Thereafter he held several curacies before arriving at Haworth in 1919. He remained in Haworth for only six years, and of all the incumbents to occupy the Parsonage, he is the least well known. It appears that he never married, and that he shared his home with his mother, Mary Ann.

Interest in the Brontës continued throughout the 1920s and it was during Elson's time that the Ideal Film Company arrived in Haworth to make the first film adaptation of Emily Brontë's *Wuthering Heights*. This was a silent film, billed as 'Emily Brontë's Tremendous Story of Hate'. The Old Hall in Haworth featured as Wuthering Heights while Kildwick Hall near Keighley served as Thrushcross Grange. The making of the film caused a great deal of excitement in the village and crowds thronged the Main Street and the area around the Old Hall hoping to catch a glimpse of the leading actors, Milton Rosmer and Anne Trevor.

Elson's thoughts regarding the Brontës have not been recorded. He left Haworth in 1925 to become Rector of St John's at Bradford, where he remained for only two years before moving to Donington. Following a career which had taken him all over the country, Elson died on 24 March 1966, aged ninety-two, at Folkestone in Kent.

John Crosland Hirst (1925–28)

The next Rector of Haworth to occupy the Parsonage was John Crosland Hirst. Hirst was born on 16 December 1886 at Meltham Mills in Yorkshire, the eldest son of Ben Hirst, an overlooker, and his wife Mary. He was educated at Almondbury Grammar School and then went to Leeds University, where he graduated with first-class honours in Classics. At the time of the 1901 census Hirst was living with his parents and brothers Harold and Edwin at 5 Manor Houses, Meltham Mills. Ten years later Hirst is recorded as a 'clerk in holy orders' living at a boarding house in Wallsend-on-Tyne. On 3 July 1913 Hirst married Emmeline Jane Milner at the parish church in Meltham Mills. Emmeline, born on 8 January 1883, was the daughter of William Blakey Milner and his wife Elizabeth Maria, of 3 Oxford Road, Guiseley. The couple had just one child, a son named William John, born at Toxteth Park, Lancashire, in 1915.

For a time Hirst was engaged in Church Missionary Society work and was principal of the Normal School at Maseno, in Kavirondo, East Africa, where he did translation work in addition to carrying out his duties as principal of the school for training teachers. After being offered the living at Haworth by the Bishop of Bradford, Hirst returned to England with his family. It must have been very difficult adjusting to life in Haworth after the heat and open spaces of East Africa. For William, the moorland behind the Parsonage must have offered some consolation. He attended Bradford Grammar School, and began to settle into his new life.

T. W. Story posed in the stocks, which for a time stood in the Parsonage garden.

Looking back on this period in preparation for a speech he was to give as part of the Brontë Parsonage Museum's diamond-jubilee celebrations in 1988, he recalled,

> Now I was living in the famous rectory ... I was used to visitors but was not particularly interested in the Brontës, more thrilled with William Grimshaw. I suppose I even reacted against the Brontës. Of course, I knew about them but was put off them by some of the visitors. I gave a lecture to my school about the Brontës.
>
> I was reading Latin and Greek (and still do). I was hoping to go to Oxford. I remember my father saying to me one day 'you can't go up to Oxford without knowing more about the Brontës'. For many years we had the habit of reading after lunch. My father was an outstanding reader and had a pleasing sonorous voice. So he used to read to me after lunch each day about a quarter of an hour or twenty minutes. Not only did he read books like Warde Fowler's *City States of the Greeks and Romans* but also English literature. Charles Dickens' *David Copperfield* ... Then *Jane Eyre, Villette* (we had a summer holiday in Belgium and went on a Brontë pilgrimage), *Wuthering Heights,* then came Mrs Gaskell's *Life of Charlotte Brontë,* followed by Mrs Chadwick's *In the Footsteps of the Brontës* – as a boy I met her.

Mrs Ellis Chadwick spent the first two years of her married life living in Haworth in the late 1880s. Her last published piece was an article entitled 'Haworth Parsonage: The Home of the Brontës', published in 1928, the year before her death. In the article she writes,

> Very few pilgrims have ever been allowed to enter the portals of this old rectory, apart from the friends of the families of the successive rectors who have lived there

On 4 August 1988 Charles Story returned to the Parsonage to take part in the diamond-jubilee celebrations. He died the following year.

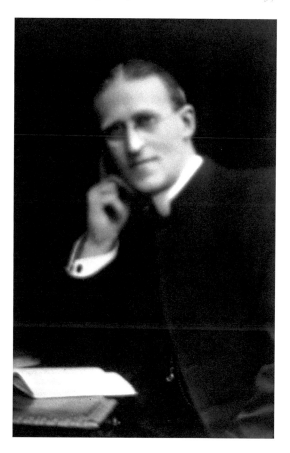

Photograph of George Alfred Elson,
Rector of Haworth, 1919–25.

G. A. Elson pictured with the Women's Guild, *c.* 1920.

Photograph of John Crosland Hirst (on the right), Rector of Haworth from 1925–47, in the Parsonage garden with Mr Aaron Fielding. Hirst was the last incumbent to occupy Haworth Parsonage before it became the Brontë Parsonage Museum in 1928.

since the Brontës. So secluded has the rectory been kept that it has acquired the reputation of being 'a mystery house', but there is nothing mysterious about it to satisfy the curiosity of an intruder.

Having had the good fortune to have lived in Haworth some forty years ago, I enjoyed the pleasure of being allowed to wander through the old home at the kind invitation of successive rectors, and recently had the rare privilege of staying as a guest at the rectory and sleeping in the room in which Charlotte died.

Although the Parsonage has been altered and enlarged, the most interesting rooms associated with the Brontës are just as they were in their days. These rooms are crowded with memories, mostly sad, though there are happy associations which linger around the family sitting-room … This room is some 4 yards square. The old fireplace has been replaced by a modern grate, and the two window seats, on which the little Brontës were wont to curl themselves up with a book, reading as long as the daylight lasted, are gone. The twelve small panes of glass in each window have been replaced by four large ones; otherwise the room is as it was in the Brontë days.

After spending the night in Charlotte's old bedroom, Mrs Chadwick wrote that it 'was, indeed, a thrilling experience to sleep in that room, which is redolent of so many sad stories'. During her stay with the Hirst family she noted that the two large

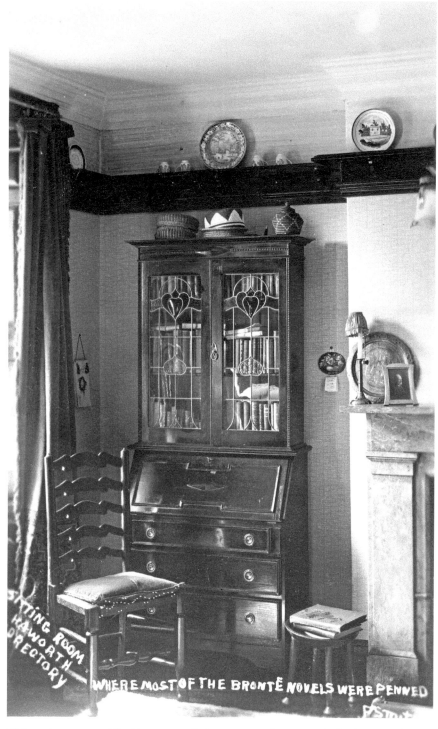

This and next page: The Parsonage dining room and entrance hall, photographed in Hirst's time and made available as postcards in an attempt to satisfy the curiosity of tourists to Haworth.

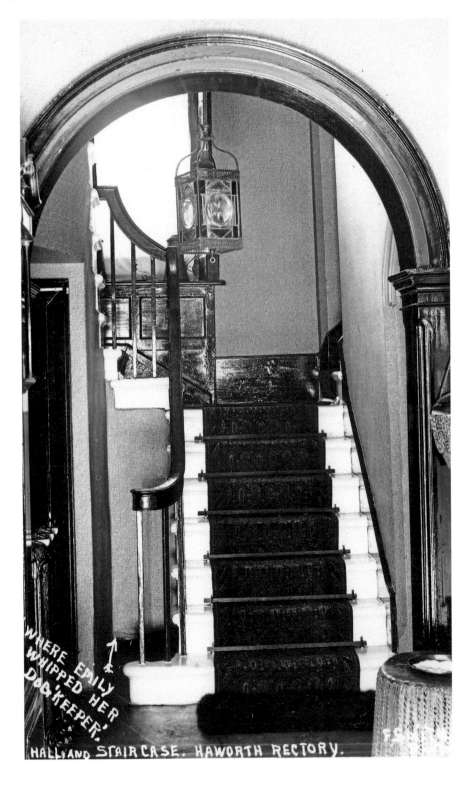

'WHERE EMILY WHIPPED HER DOG 'KEEPER'.

HALL AND STAIRCASE. HAWORTH RECTORY.

The Reverend J. C. Hirst (left) and Mr Aaron Fielding pictured outside the Parsonage.

pewter flagons, which had been used for the wine at the communion service by William Grimshaw, were sitting on the sill of the tall staircase window. The flagons are visible in a photograph of the entrance hall which was made available as a postcard around 1926, showing that much of the woodwork in the house had been stained dark, and that souvenirs of the Hirsts' time in Africa were displayed around the house. An African drum served as a hall table and African baskets were displayed on top of the glass-fronted bookcase in the dining-room. Chenille curtains hang at the dining-room windows and a delft rack, laden with china, runs round the room. William Hirst recalled other visitors who had been equally impressed by time spent at the Parsonage:

> I have a cousin, Brenda Hirst, who was staying with us at the rectory and she always says she learned to walk in Charlotte Brontë's bedroom. Miss Gertie Whitley who helped us slept in Rev Patrick Brontë's bedroom and was so proud of it.

The Brontë Society had always hoped that one day they would be able to acquire Haworth Parsonage. By 1927 the Society's collection had outgrown the cramped quarters above the Yorkshire Penny Bank. An approach was made to the church authorities, who indicated that they would be willing to consider selling the Parsonage for the sum of £3,000, which would enable them to build a new home for the vicar. The story of how Sir James Roberts stepped in and provided the necessary funds is now well known; not so well known is how the family living in the Parsonage at the time felt about having to leave their home. William Hirst recalled that

William Hirst and his wife were present for the diamond-jubilee celebrations held at the Parsonage on 4 August 1988.

THE KEIGHLEY NEWS, SATURDAY, 11 AUGUST, 1928.

AT THE BRONTE MUSEUM OPENING.

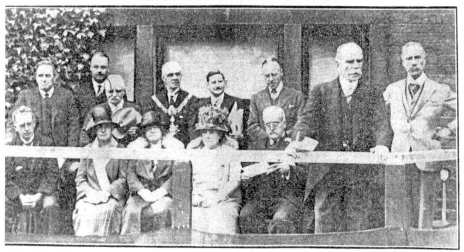

View of the platform during Sir James Roberts's address at the opening of the Brontë Parsonage Museum and Library last Saturday at Haworth. Among those included in the picture are Sir Edward Brotherton (seated next to Sir James), Lady Roberts, the Lord Mayor and Lady Mayoress of Bradford, the Mayor and Mayoress of Keighley, Mr. Coulson Kernahan (on Sir James's left), and Mr. J. A. Symington (in the centre at the back).

Photograph: G. Crowther, Keighley.

Sir James Roberts purchased Haworth Parsonage in 1928, and on 4 August thousands turned out for the official opening of the Brontë Parsonage Museum.

in 1927 Mr Michael Merrall came one morning and told us he had sold the house to the Brontë Society and 'we are going to build a new rectory for the rector' ... The building went on at the end of 1927 – but unfortunately in a gale a wall was blown down and things were consequently held up.

One day Mr Merrall came to what was still the Rectory and the following arrangements were made. The Brontë Society was anxious to proceed with alterations, especially the fireproofing of a room (first left) to house the Bonnell collection. So Father and Mother stayed with Mr Merrall at Law House for some weeks. His housekeeper did not like children so I had to stay at Thornville in Bradford and with various friends at weekends. It will not be a cause of surprise if I say as a schoolboy I'd been kicked out of the house. It was my home, I liked it and the life there.

The Hirst family was extremely resistant to making the move from the Parsonage. They eventually settled into the new rectory and forgave the Brontë Society; William joined the Society and his father became a member of its council. John Crosland Hirst was still Rector of Haworth at the time of his death on 17 August 1947. He had acted as Officiating Chaplain to the forces stationed at Haworth during the war, and had been planning a service to be held at the church celebrating the centenary of the publication of *Jane Eyre* and *Wuthering Heights*. His wife Emmeline survived him by nearly thirty years, dying in 1975 at the age of ninety-two.

Five

Harold Mitchell:
1928—1961

We never saw 'the family next door', but we felt they existed.
Eric Mitchell, unpublished notes and observations.

Shortly before the Brontë Society's acquisition of Haworth Parsonage, Fred Smith, who had acted as caretaker of the museum above the Yorkshire Penny Bank building, announced his resignation. This meant that as well as converting the Parsonage into a museum and planning the opening celebrations, the Society's council also needed to find a custodian for the building.

The man appointed was Harold Gilliam Mitchell, a thirty-two-year-old ex-serviceman. Mr Mitchell was the eldest of five children, born at Batley, West Yorkshire, in 1896. When Harold was still a child his father William landed a job on the editorial staff of a newspaper based in Dublin, and the family uprooted and moved there. The post must have been relatively well-paid, for Harold was educated by a private tutor with connections to Trinity College, and it appears that he was able to make use of the facilities there and even attend lectures at the university. Once his school days were over, Harold was indentured to a tailor who included several wealthy, titled people among his customers. Harold was initiated into the art of making gold insignia, and he also learnt all the tricks of the trade with regard to judicious padding, and creating the most flattering fit. After his father published an unfortunate article attacking Sinn Fein in 1914, the family was obliged to make a hasty return to England.

The Mitchell family began a new life in Darlington, where William Mitchell accepted a less lucrative position as agent for the *North Star & Darlington Outlook* and Harold began work for another firm of tailors. In February 1916 he enlisted in the King's Own Yorkshire Light Infantry, and, after basic training, found himself in the trenches in Flanders. In an attack on Loos in 1917 he lost his right hand after catching a grenade which he was unable to get rid of in time. He was discharged from

active service and, returning to Darlington, found that like many other wounded ex-servicemen, he attracted plenty of sympathy but few employment prospects. He had always shown a talent for art and, despite his injuries, re-trained as a commercial artist in Halifax, lodging with an uncle who ran a confectionery business in the town. Back in Darlington, he took on any work he could get, and it was at this period he met and married Mary Ellen Seaman. Following their marriage in 1925 the couple moved into rented rooms in Leeds, where they believed there would be better prospects of employment. After much searching and disappointment Harold applied for the post of caretaker at the Brontë Parsonage Museum.

The interview took place in Bradford, and Harold acquitted himself well. His knowledge of literature and art stood him in good stead and he was offered the job. Harold already knew Haworth from walks he'd taken over the moors during his time in Halifax, and on a September evening in 1928 the Mitchells, along with their small son Raymond, moved into the few cramped rooms in the Wade wing of the Parsonage.

As well as settling into their new living accommodation, the Mitchells found there was a huge amount of work to be done establishing order in the recently opened museum and finding a home for the Society's collection of artefacts, which had been transferred from the Yorkshire Penny Bank building. In those early years, visitors to the Parsonage numbered around 4,000 annually, and Mr Mitchell would admit them, issuing tickets and serving in a little kiosk selling postcards and souvenirs in the Brontës' old kitchen. After the last visitors had left there was still work to be done. The Museum boiler required regular maintenance, there was correspondence to be dealt with and the banking to do. With Mary's assistance Harold cleaned the building and cared for the contents, often working into the night arranging the Museum displays. He also built up a fund of knowledge on Haworth and the Brontës which he was always willing, and frequently called upon, to share.

Two more sons were born at the Parsonage: Trevor in 1930 and Eric in 1935. Bringing up three boys in a literary shrine must have been very difficult. Noisy games had to be curtailed, and from an early age the boys were very conscious of what they called 'the family next door'. A single glass-panelled door separated the Mitchells' living accommodation from the original Parsonage. 'Whenever you opened that door,' Eric recalls, 'you were stepping into a different, hushed place; with its stone flagged floor it was different, it even smelt different.'

Harold and Mary's involvement in village life meant that the family's living space was further crowded by a constant stream of friends and visitors to the house. They were both involved with Haworth church, and Harold was a teacher at the Sunday school. He produced amateur dramatic shows for Mill Hey Methodists, Haworth Baptists and other church organisations, and is still remembered in the village as the local Group Scoutmaster. Animals also played a prominent part in Parsonage life, just as they had during the Brontës' time. There was always a dog, and a more unusual pet was a tawny owl named Wha-bit (pronounced 'Warbi', a Red Indian name meaning 'keen eyes'), found by Raymond in Springhead Wood with a damaged wing, and brought home for his father to nurse back to health. The owl survived but

Harold Mitchell in Charlotte's room at the Parsonage.

The Mitchell family in the Parsonage garden, *c.* 1933. From left to right: William Gilliam Mitchell, Mary Ellen Mitchell, Trevor (sitting at his mother's feet), Alice Florence Mitchell, Raymond (sitting at his grandmother's feet) and Harold Mitchell.

refused liberty, and opted to remain at the Parsonage instead. The little owl was a great attraction with the local children, who would help the Mitchell boys dig for worms to feed it with. Raymond made a perch for Wha-bit on the kitchen delft rack where sometimes, after a long period of absolute stillness, the owl would suddenly take flight to the alarm of visitors. Eric also kept white mice in the old privy at the back of the Parsonage, which still survived in those days and also housed the boys' bikes.

During the war years the Parsonage remained open. The works of the Brontës were widely read, with cinema adaptations proving extremely popular. 1939 saw the release of Samuel Goldwyn's *Wuthering Heights*, starring Laurence Olivier and Merle Oberon. *Devotion*, a film based on the Brontë story, was released in 1943, and the popular film adaptation of *Jane Eyre*, starring Orson Welles and Joan Fontaine, was released the following year. These films had an impact on visitors to the Parsonage so that despite the advent of petrol rationing, visitor figures rose from 9,000 in 1940 to 22,945 in 1945. The dining-room, home to Henry Bonnell's magnificent collection of Brontë manuscripts, drawings and books, had its ceiling strengthened and windows blocked up in anticipation of enemy action. Troops were stationed at the new Sunday school in Haworth which stood across from the Parsonage (the building was demolished in 1965). The Parsonage was one of a small number of Haworth homes which had a bathroom, and Eric remembers small groups of soldiers congregating in the family's sitting-room, waiting their turn for a bath. The hot water was generated by a fire-back boiler in the sitting-room, the same

The Mitchell family pictured in their sitting room at the Parsonage, *c.* 1943. Left to right: Raymond, Mrs Mitchell, Eric, Mr Mitchell and Trevor.

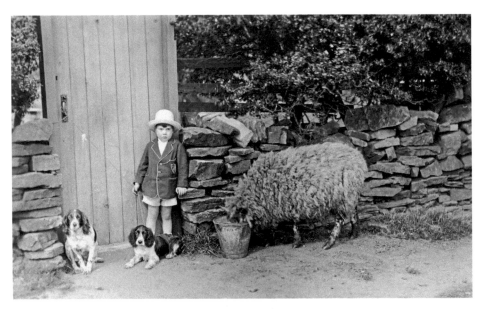

Raymond Mitchell pictured with an assortment of animals by the allotments at the back of the Parsonage.

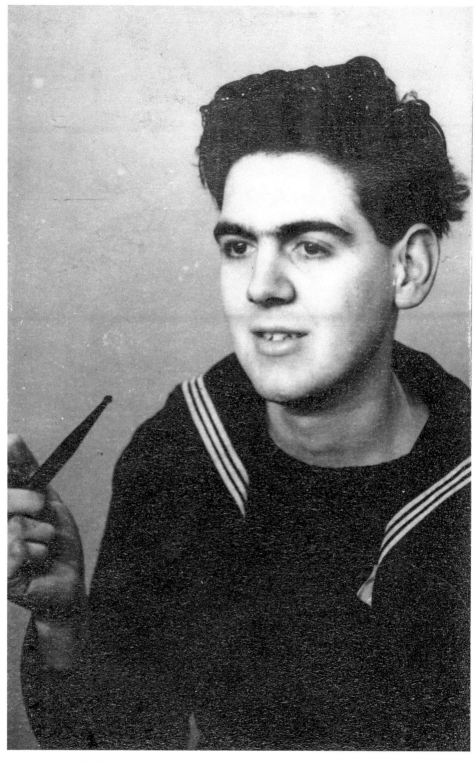

Raymond Mitchell photographed shortly before his death in 1945.

The little owl, Wha-bit, on its perch in the Mitchells' kitchen at the Parsonage.

fire on which Mrs Mitchell did all the cooking and baking. While Eric fed logs into the fireplace, the soldiers would tell him stories of army life and their families back home. On these occasions Eric often thought about Raymond, who had volunteered for military service and joined the Royal Navy Fleet Air Arm in 1943.

On the evening of 9 November 1945, Eric and some other boys had been riding their bikes around the top of Haworth. On realising that it was nine o'clock and that he was going to be late home, Eric dashed back to the Parsonage and after putting his bike away in the shed, sneaked back into the house through the scullery, hoping to avoid a telling-off. It came as quite a shock to find his parents, along with Trevor and some of their neighbours, all gathered together in the sitting-room, and very shocking indeed to see his father was crying. In fact they all had tears in their eyes. His mother gently put her hand on Eric's shoulder, saying, 'We got a telegram...'

Earlier that day Raymond Mitchell had been killed in an accident at a naval land base in Ayr, Scotland, the circumstances of which still remain a mystery. The telegram informing the Mitchells of his death had been passed to the Reverend Mr Hirst, so that he could break the devastating news in person. The news quickly spread around Haworth and neighbours came to offer their support.

The next few days were a terrible blur for the family. The shocking tragedy was made real by the arrival of Raymond's coffin, escorted by two of his comrades. Eric remembers his father going to view his son's body, before the coffin was placed in Haworth church, draped in the union flag. Barbara, Raymond's fiancée, arrived from Walsall, and Eric was tasked with looking after her. The two of them set off on a walk which unfortunately led them past the church. Barbara pulled away from Eric and dashed inside, and the shocked boy was witness to a scene of harrowing grief never to be forgotten.

Many relatives and friends arrived in Haworth for Raymond's funeral on 13 November. Raymond was buried in the cemetery out on the moors and Eric was deeply shaken by the solemnity of the occasion and the sight of the open grave. Following the burial ceremony the mourners gathered at the Sunday school where, despite rationing still being in force, trestle tables were heavily laden with food. Trevor, suddenly cast in the role of eldest son, felt his responsibilities keenly and gave support to his parents. Eric was utterly bewildered by the crowd of relative strangers, chatting and eating and seemingly enjoying themselves. He fled the room, running up Church Street past the Parsonage and taking the footpath over the fields where not so long ago Raymond had taught him to ride his bike. A kindly neighbour sought Eric out and after a sympathetic chat, she escorted him back to the schoolroom to take his place with his family.

On the day of Raymond's funeral the Parsonage remained open, with a local man stepping in to take charge. In fact the Parsonage closed for only one day a year, at Christmas, and even then Eric remembers the family's Christmas dinner being interrupted by visitors requesting tours of the house (Brontë Society members being the worst culprits!). Harold and Mary's annual holiday was conditional on their finding a replacement to run the Parsonage. As Trevor and Eric grew older and began work themselves, a local person would run the Museum until they returned from work and took over in the evening. On one of these occasions there was a terrible thunderstorm and rain poured into a small first-floor store room, partitioned off from Branwell's studio. Midnight found the Mitchell boys at work with mop and buckets, and Trevor was still repairing the damage at 6.30 the next morning when Eric left for work.

Towards the latter part of Harold Mitchell's time at the Parsonage the visitor numbers had increased dramatically, rising from around 4,000 in the early days to 46,703 at the time of his retirement in 1961. This meant a huge amount of extra work, and as Mr Mitchell was without an assistant at this time, Trevor was often drafted in, helping to issue tickets at the front door and sell postcards at the kiosk. During these years the front door of the Parsonage provided the only means of entrance and exit, a fact which caused a great deal of inconvenience to visitors, and Trevor would also help his father regulate the number of visitors in the upstairs rooms. Trevor had followed a career in horticulture and his assistance was also called on to keep the Parsonage garden in trim.

Mr Mitchell had trained himself to write with his left hand, and as his knowledge of the Brontës and the Museum collection grew, he often assisted Wyndham T. Vint, the Museum's Honorary Curator, in dealing with correspondence. One of the great perks of working at the Parsonage is the opportunities it brings to meet famous and interesting characters. 'You don't know who's going to be behind the door when you open it,' Mr Mitchell once remarked. 'It may be royalty or an actor or just the usual man-in-the-street seeking knowledge.' Over the years Eric remembers meeting a host of great names including Charlie Chaplin and Orson Welles. One of his earliest memories is being photographed on the Parsonage steps in the arms of James Roosevelt, son of the American president, who visited Haworth in 1939. Daphne du Maurier was one of many writers who came to research the Brontës. On her

This photograph shows the Brontës' kitchen with John Wade's dining-room extension beyond. When the house became a museum in 1928, the dining-room was used as a research library and the old kitchen housed a display of the Brontës' kitchen furniture and a kiosk selling postcards and souvenir items.

visits to Haworth she would sit in the Mitchells' sitting-room discussing Branwell and the authorship of *Wuthering Heights* with Harold. Their talk would go on into the night, and if he stayed very quiet, Eric's presence would often be forgotten. The family continued to receive Christmas cards from du Maurier for several years after her Branwell biography appeared.

In 1959 changes were made to the interior of the Parsonage in an attempt to recreate the appearance of the Brontës' home. An extension, not visible from the front of the Parsonage, was also added, and the Wade wing, which had provided cramped accommodation for the Mitchell family, could now be converted into exhibition space. The new extension included a flat for the custodian, connected to the old Parsonage by a glass loggia. Although the arrangement provided desperately needed space, and great care had been taken with the materials used, any changes made to the famous Parsonage have always aroused controversy. A letter printed in the *Times Literary Supplement* accused the Brontë Society of 'deplorable vandalism' and among the most hostile opponents of the redevelopment were Winifred Gerin and John Lock, both Brontë biographers who lived in Haworth. Phyllis Bentley, a Brontë Society Council member, defended the alterations on the BBC Radio's *Woman's Hour* programme:

A substantial extension at the back – out of sight from the front of the house – has been built to house the Bonnell Collection and other relics, so as to leave the Parsonage rooms free … But it's the Parsonage itself I particularly want to tell you about. The old kitchen, where the little Brontës first began telling each other stories, has now been restored to its original shape, and has a kitchen range dating from their time, and some of their own china. Upstairs Branwell's bedroom exists as a room again. The Parsonage windows have been re-glazed with small panes, so that we now look through the same kind of windows the Brontës looked through … The dining-room, where the sisters did most of their writing, has now the chairs the Brontës sat on and the table they used and the couch on which Emily died, and a high narrow fireplace as near as possible to their fireplace, and their pictures and books, and in the wallpaper and furnishing 'crimson predominating', as Mrs Gaskell said when she visited Charlotte in 1853.

In the Society's possession there are some scraps of paper painted by Charlotte in delicate patterns – they might be dress material patterns, but more likely patterns for wallpapers. At any rate they represent Charlotte's taste, and we've tried to get wallpapers of similar taste for the dining-room and Charlotte's bedroom. On her marriage, Charlotte 'did up' the little back room downstairs in green and white for her husband's study, so we have done it in the same colours. In Branwell's bedroom, when the decorators stripped the walls a wallpaper contemporary with the Brontës emerged, and that has been copied as nearly as possible.

In the same way, when the successive layers of paint in the hall were removed, the lowest layer was found to be pale blue, so this same colour of blue has been applied.

After all the upheaval of the building work, the Mitchells were finally able to move into their new flat. Eric, who had been posted to Malta on army service, arrived

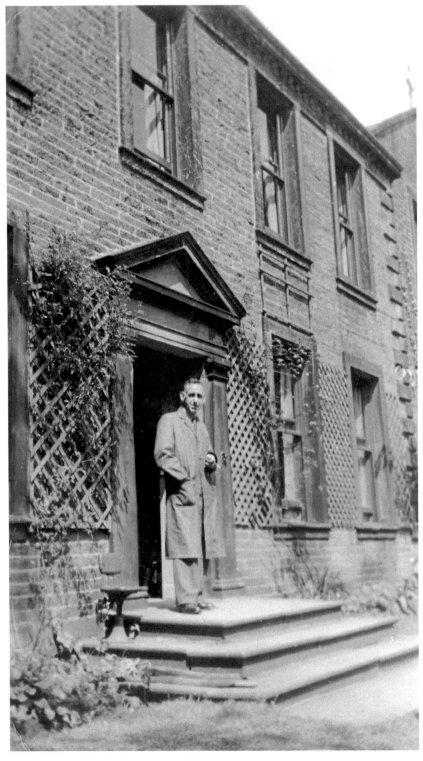

Harold Mitchell at the front door of the Parsonage, 1949.

On 4 August 1988, the Mitchell family returned to the Parsonage for the diamond-jubilee celebrations. Left to right: Trevor, Mrs Mary Mitchell, Eric's wife (also called Mary) and Eric.

home unexpectedly one dark November evening only to be confronted by a solid wall in place of the door he had expected to find there. Luckily a sliver of light was visible from the scout hut in the Sunday school grounds, and groping his way towards it, Eric was relieved to encounter Trevor, who was able to guide him to the new flat.

The Mitchells remained in their new home for only a brief time; on 1 May 1961 Mr Mitchell handed over the Museum keys to his successor and left the Parsonage to begin his retirement in the nearby village of Denholme. He had lived and worked at the Parsonage for thirty-three years and seen many changes. Both he and Mary were sad to be leaving their home, but Harold looked forward to having time to work on his drawing, painting and design work. One of Harold Mitchell's lasting memorials at the Parsonage is the iconic wrought-iron sign depicting Charlotte at her writing desk, which overhangs Church Street on the gable end of the Parsonage. This was designed by Mr Mitchell and produced by Herbert Scarborough, the Haworth blacksmith. The sign was originally hung on 18 March 1938, and shortly after had to be taken down for the duration of the war.

In 1969 the Mitchells returned to Haworth, moving into a cottage on West Lane, very happy to be living close to the Parsonage. Sadly Harold Mitchell died suddenly only a few weeks later on 11 October and was buried in the cemetery on the moors with his son Raymond. Mary remained in Haworth for many years, dying in 1995 at the age of ninety-eight.

Geoffrey Beard and Joanna Hutton: 1961–1968

...it was rather like moving to the White House if one lived in Washington.
Joanna Hutton, *Memories of a Brontë Curator*, unpublished memoir.

In February 1961, following Harold Mitchell's retirement, the post was upgraded and Geoffrey Beard, Assistant Keeper of Leeds City Art Gallery, was appointed as Curator of the Brontë Parsonage Museum, moving into the new flat at the back of the Parsonage with his wife Margaret and their young daughter Helen.

A multitude of skills were required of the small staff running the Parsonage in those days. Harold Mitchell had relied on the assistance of his family but as a museum professional with a background in fine art, Mr Beard must have been frustrated to find that once a week he was expected to do duty for the doorman at the Parsonage, sweeping floors and selling tickets on the front door. What was more, his wife was not happy living in Haworth, and after eighteen months of working at the Parsonage, he resigned.

Geoffrey Beard's resignation created a serious problem for the Brontë Society. Recruiting his replacement was likely to take some time, and in that period before the introduction of electronic security, would leave the Parsonage building unoccupied and vulnerable. Also, without someone to take charge, the Society may well have been forced to close the Parsonage.

Into this breach stepped Joanna Hutton, a thirty-year-old life member of the Brontë Society, who was already living in Haworth. Joanna had first visited Haworth and the Parsonage as a child when she and her mother were evacuated from Folkestone to Leeds. 'My main memory of the Parsonage on that visit of 1942 is of the dank smell associated with uncertainly heated houses and the smallness of Charlotte's clothes,' Joanna later recalled, adding, 'Naturally the highlight was the horsehair sofa on which Emily died.' Joanna soon came to share her mother's interest in the Brontës and Emily Brontë in particular.

Joanna was born into an acting tradition. Her father, Arthur Brough, was the founder of the Brough Players, and probably best known today for his TV role as Mr Grainger in *Are You Being Served?* Her mother, Elizabeth Addyman Brough, was also an actor and author of several plays. Joanna's school days were spent at Leeds Girls' High School and Ashford School for Girls with a spell in Switzerland before she went on to train at the Webber Douglas School of Drama in London, followed by a stint working in repertory theatre and taking on small parts for television productions. Her love of the Brontës never quite left her, and after marrying Tony Hutton, a Yorkshire man, she made the move to West Yorkshire, spending her early married life in Bradford. After she read Winifred Gerin's biography of Anne Brontë in 1959, Joanna's enthusiasm for the Brontës became a passion. She made frequent visits to Haworth and eventually the couple bought a house there. In May 1960 Joanna and Tony, along with their children Jonathan and Caroline, moved into their new home in Bridgehouse Lane. A third child, James, was born later that year.

Soon after the move, Joanna joined the Brontë Society and immersed herself in the Society's activities and Haworth life generally. She became friendly with the Beards, and when Geoffrey Beard told her that he would be leaving Haworth to take up a new appointment, she knew she wanted to apply for the post at the Parsonage. Her conversations with him meant that she had a good grasp of the work that would be involved, and he believed that she would be able to do most of what was required. He did, however, warn her that the professional librarians on the Brontë Society Council felt that they had scored a victory by his appointment, and would not easily accept an unqualified curator. Undeterred, she applied for the job.

Joanna was visited at home by Donald Hopewell, President of the Brontë Society, accompanied by Sir Linton Andrews, the Chair of Council (who later became one of Joanna's staunchest supporters), and two other members of the Brontë Society Council. It was suggested to Joanna that she should become Geoffrey Beard's assistant for the remainder of his time in Haworth, and then move into the flat at the Parsonage and continue to deal with the day-to-day running of the Museum until a permanent appointment could be made. As the arrangement might turn out to be a temporary one, this was asking a great deal, but Joanna agreed to the proposal with characteristic enthusiasm: 'I was too far in, too keen to get the job to falter at any obstacle ... I realised too that those Council members who now wanted me felt that once moved in, my position was infinitely stronger, possession being nine tenths of the law.'

Joanna's work at the Parsonage began on Monday 29 October 1962, and copious notes she made over the following weeks show her determination to get to grips with the job and the many areas where she felt improvements could be made. They also show the staggering amount of work she had taken on. Apart from the Curator, the Museum staff consisted of Mr Bairstowe, who worked full-time, cleaning the floors and selling tickets on the Museum door (later replaced by Harry Parke), and Mrs Hollindrake (known to Joanna's children as 'Mrs Orangecake'), who helped part-time with the lighter cleaning and ran the postcard kiosk. Amy Foster, the Yorkshire Archaeological Society librarian from Leeds, was brought in as Honorary

Joanna Hutton in the kitchen at the Brontë Parsonage Museum, 1964.

Archivist and came to Haworth once a fortnight to catalogue the Society's collection of Brontë manuscripts. All the Society's administration and accounts were dealt with by Beatrice Stanley, a former bank employee, at her home in Keighley.

At the end of November Mr Beard left the Parsonage to take up his new post at Cannon Hall in Cawthorne, near Barnsley, and the Huttons prepared to move into the Parsonage flat. The week of the move, Joanna was hospitalised with pneumonia, leaving Tony to tackle it single-handed. The children, by now joined by baby Sarah, and all being cared for separately by relatives, got measles, and their cat Jimmie took an instant dislike to the Beards' half-wild cat Willy, who had been inherited with the post. Until a final decision about the curatorship had been reached, the Huttons were reluctant to move all their belongings into the flat, and for the next few months found themselves living between two homes. The day of the interview finally dawned and the following description is taken from Joanna's memoir:

> The winter of 1962–63 was bitterly cold; the snow lay deep upon the ground until March. It was not therefore until 23 February that the decisive meeting was held; and even then, because of the weather, it had to be at Leeds City Art Gallery … there was only one other candidate for the curatorship. She was a Mrs McLean, a very affable lady, a widow of fifty-three from Edinburgh … We had to sit in a room next to the Council Chamber until we were called for our interviews. Mine was painful in the extreme. I was asked the most condescending and belittling questions such as 'Can you type Mrs Hutton? Have you got your school certificate? You do realise that without your school certificate you can do nothing in the museum world?'
>
> Mrs McLean then went in. When she returned we sat making polite conversation to each other for what seemed like an everlasting age, while all hell was let loose next door. There was shouting, the noise kept reaching a crescendo, then short silence, then mounting noise. Eventually the President, Donald Hopewell and the Chairman of Council, Sir Linton Andrews came to us. They said that I had got the job … I was then told that six of the eight people who had voted against me had resigned from the Council, notably Phyllis Bentley, the novelist, and, of course all the librarians.

By the time Joanna got back to Haworth, the press were already preparing colourful accounts of how the Council of the Brontë Society had appointed a 'young actress' as Curator of the Parsonage Museum and that six of its members had resigned in protest. For the next few days the telephone continued to ring and journalists loitered in Church Street. One French academic, in a letter to the *Times Literary Supplement*, likened Joanna's appointment as Curator to putting 'Miss Brigitte Bardot in charge of the house of Victor Hugo'. Feelings ran high, and letters from both sides raged in the press until April. Tensions continued to rise as the date set for the Society's AGM approached. Winifred Gerin and John Lock still lived in the village and were said to be petitioning support against Joanna's appointment. The meeting was expected to be a stormy one, but in the event, the petition was not presented and the expected disruption never materialised. During her short

Tony with Caroline and James at the back of the Parsonage.

time working at the Parsonage and dealing with the daily correspondence, Joanna had already won support and many new friends. That evening she returned to the Parsonage triumphant. 'Looking back it was one of the happiest evenings of my life … It was a turning point: the beginning of an exciting, happy and very fulfilling period of my life.'

It was also one of the busiest periods of Joanna's life, and she achieved a huge amount during her years at the Parsonage. Her appointment coincided with an unprecedented rise in visitor figures (52,000 in 1962 rising to 97,164 in 1968), and gradually all Society matters came to be handled at the Parsonage, adding considerably to the workload. With the exception of Liz Parker, who came to assist with secretarial work, the workforce did not increase. Liz provided vital assistance to Joanna both in running the Parsonage and in childcare. The Hutton children came to love her and she was regarded as part of the family. 'We worked so hard to make everything perfect,' Liz recalls, 'so there would be no way the "enemy" would have ammunition to attack Joanna's appointment.' As well as giving talks to the many visiting groups, Joanna also had to deal with the many requests for information. Initially, the research enquiries were dealt with by Council member Edith Weir, but soon Joanna was confident enough to deal with them herself. One of her early innovations was to clear out the Parsonage cellar and turn it into a space where a slide show and short talk could be presented to visiting groups. Among bags of soot and thirty years' worth of accumulated rubbish she discovered C. W. Hatfield's typed transcripts of Emily's poems, which are now part of the library collection. Despite the long hours and hard work, Joanna found that 'once the unpleasantness of the controversy was over and all our belongings were in one place, we were able to enjoy life once again. It was a delight to live in the Brontë

home and be able to browse through the library and the stock book in the evening, when the children were in bed.'

One further challenge still had to be faced, however. This was a visit from Helen Bonnell, widow of the wealthy American collector Henry Houston Bonnell. Acting under the terms of his will, Mrs Bonnell had despatched a large proportion of her husband's wonderful collection of Brontëana to the Parsonage Museum, and retained an active interest in its preservation and display. Alarmed by the controversy surrounding Joanna's appointment, Mrs Bonnell decided to inspect the recently created Bonnell Room at the Parsonage and meet the new Curator at the same time.

> I remember well the day before Mrs Bonnell's visit: our desperate efforts to get everything just so. The eleventh hour arrival of the commemorative plaque and, horror of horrors, Mr Parke had applied the stone polish to the plastic flooring. I was on my hands and knees trying to amend this final disaster ... when I glanced up at the newly erected plaque only to discover that the date of Mr Bonnell's death was incorrect.

Despite these setbacks the visit passed off well. Mrs Bonnell was entertained in the Parsonage flat and when Joanna eventually left the Museum, she wrote to say that she couldn't imagine the Parsonage without her. Sadly it was to be Mrs Bonnell's final visit to Haworth; she died suddenly the following year.

Living on the premises meant that Joanna, like the Mitchells before her, was never off duty and suffered the regular inconvenience of visitors turning up outside museum opening hours and demanding admittance, which she claimed had left her with a pathological dread of 'dropper ins'. In her memoir she wrote about one memorable intrusion:

> Another evening, at 9 o'clock, after a very busy day, there was a knock, once more on the kitchen door. On my way to answer it I said, 'If it is the dear queen herself I will not let her in.' I opened the door to see an elegant gentleman, dressed in navy blue, with a pink satin cravat, silhouetted against the sunset and the dustbins. He said, 'I am a photographer, my name is Beaton. Please could I see round the Museum?' I ran through to open the Parsonage gate for him, shouting to Tony, 'It's not her Majesty, just her photographer!'

Combining a demanding full-time job with bringing up four lively children in a few cramped rooms was an exhausting business. When the Huttons managed to get away for a holiday, Liz would be called in to take charge. 'I can remember having to stay in the flat when the family were on holiday as it couldn't be left unattended,' Liz remembers. 'It was quite scary for an eighteen-year-old on her own with the sign creaking in the wind ... going round the Museum at night to close up was very creepy. I had severe scares when the young policeman, who had been asked to keep a special eye on the building, would come round and rap on the window to attract

Above left: Sarah, James and Caroline Hutton outside the Parsonage flat, *c.* 1965.

Above right: Joanna Hutton on the Parsonage steps.

my attention. He thought he was onto a good thing … coming in for tea and a gossip rather than patrolling the cold streets of Haworth.'

The Parsonage flat became even more crowded in 1965 when Joanna and Tony adopted Mary and Chris, sixteen-year-old twins whose mother had recently died. The pressures of caring for the family combined with long hours of work inevitably took their toll on Joanna's health: ' I was trying to do incredible hours in the Museum because we lived on the premises,' Joanna recalls in her memoir. 'I could not sleep as my mind was hyperactive and often I worked on the show-cases deep into the night.'

In 1968 Joanna took the decision to leave the Parsonage and start her own business. She set up the Museum Book Shop at the top of Haworth's Main Street, in the building which had once been the apothecary's shop where Branwell Brontë purchased laudanum. Joanna's involvement with the Brontës continued; in 1970 she and Tony were both elected on to the Brontë Society Council and in 1994, Joanna became a Vice-President of the Society. Joanna retired from business in 1987 but apart from a period living near Skipton, much of her retirement was spent at Haworth. Her knowledge of Brontë matters meant that she continued to be sought out by researchers and Museum staff. Joanna Hutton died in 2002 following a brave fight against the ravages of motor neurone disease.

Norman Raistrick:
1968–1981

...being the custodian of the Brontë Parsonage Museum isn't just a job. It's a way of life!

Norman Raistrick, interviewed by Louise Brindley, 1981.

At the time of his appointment as Custodian, Norman Raistrick was already working at the Parsonage after replacing Harry Parke as doorman. He slipped quietly into post without any of the controversy which had accompanied Joanna Hutton's appointment.

Norman Raistrick was born at Lees, near Haworth, in 1906, one of the seven children of Richard Hodgson Raistrick and his wife Alice. Norman's wife, Amy, also born in 1906, was part of another large family from nearby Ingrow. Both Norman and Amy experienced family tragedies while still young; Norman's brother Sydney and Amy's youngest sister, Effie, both died in childhood, and Amy's father, Percy Shackleton, was killed in action during the First World War. After his death the Shackleton family moved to Haworth Brow. Norman and Amy met when they both attended Lees school. Their school days ended shortly before their thirteenth birthdays; thereafter Norman's education continued part-time at Keighley Technical School learning office skills, combined with part-time work in the office at Merrall's Mill in Haworth. For a time Amy worked in the mill, but she had a flair for needlework and embroidery and went on to train as a milliner. The couple were married on 14 February 1933 at St James's church, Crossroads, and made their home in a rented mill house on Haworth Road. Their first child, Noreena, was born in December 1936 followed by Jean in February 1940. Jean recalls a happy childhood surrounded by a close network of family and friends.

Mr Raistrick was now working as a commercial traveller, selling the worsted cloth produced at Merrall's Mill. He was provided with a firm's car to make the journey to Bradford and Leeds and the many mills between. Sometimes he travelled further

Norman Raistrick (on the right) photographed in an interview with Brian Johnston for the radio programme *Down Your Way*, in Mr Brontë's study, 1978.

Mr and Mrs Raistrick in the Parsonage flat with their grandchildren, Christmas 1969.

afield to Glasgow, Edinburgh and London. A telephone was essential for making appointments and its installation made the Raistrick family unique in the Haworth Road area. Outside working hours Norman had a range of interests: he served on various committees, he played snooker and cricket, he sang tenor in the choir at Lees Methodist church, also taking part in many amateur plays and, in the 1950s, he became involved with the local Gilbert and Sullivan productions. He and his family also enjoyed a lively social life centred on the church. In later life he became a Freemason, initiated into the Lodge of the Three Graces at Haworth (Branwell Brontë was initiated into this same lodge in 1836).

In 1952 the Raistricks were able to buy a stone-built house on Mytholmes Lane in Haworth, which had formerly been home to the mill manager at Merrall's. The house came with a good-sized garden and was a source of great pride. In those days virtually everything the family needed could be found in Haworth. The Main Street boasted a butcher's shop, Southam's for bread and cakes, Seth Snowden's greengrocer's and there was a hairdresser, chemist and a range of other shops on Mill Hey. There were two cinemas in the village and a library on Gas Street. Beyond Haworth there were family holidays in Morecambe and St Anne's, with excursions to London and trips to the Festival Hall and the ballet. Jean remembers that her father's favourite show was *Salad Days*, which he saw at least seven times. At the age of sixteen, Noreena started work for the Inland Revenue while Jean stayed on at Keighley Girls' Grammar School to take her A-level exams, followed by teacher-training college in London. Noreena married in 1959, spending several years living in Kenya with her husband John. Jean returned from London and began her teaching career at the school at Long Lee, near Keighley. She married in 1963.

In 1964 Norman Raistrick suffered a terrible blow when, after working for Merrall's for more than forty years, he was made redundant at the age of fifty-eight. Jerome's of Shipley had taken over the business and Mr Raistrick's position was absorbed by their sales team. Albert Preston and Arthur Hartley, both fellow masons, were also members of the Brontë Society Council and suggested he apply for part-time work at the Parsonage. Mr Raistrick was taken on at the Museum. He was hard-working and level-headed, with many practical skills. These did not include housework, and his wife and daughters couldn't help but smile on learning that his new duties involved some cleaning and polishing of brass. He enjoyed his work and when Joanna Hutton resigned in 1968, Norman applied for the position, which had reverted to 'custodian'. He was interviewed and offered the post.

After selling their house in Mytholmes Lane, the Raistricks moved into the Parsonage flat. The feeling that he was needed meant a great deal to Norman Raistrick and he threw himself into his new role with enthusiasm. For Amy it was a more difficult adjustment; not only had she exchanged her own comfortable house for the flat, but she quickly discovered that her husband was on duty most of the time. Amy missed her former neighbours and felt isolated at the Parsonage, where she was not part of the everyday running of the Museum. She would help out with any work she could, arranging flowers for the Brontë chapel in the church, and the skills she acquired as a milliner came in useful in repairing Charlotte Brontë's blue-

Mrs Raistrick and her daughter, Jean, with grandchildren Chris and Judith, outside the flat.

sprigged dress and making protective covers for the set of Hepplewhite dining chairs which had once belonged to Ellen Nussey. Mr Raistrick found the Council very supportive, and a group of them would congregate in the flat for a sherry after their meetings. He was also supported in his new role by his niece, Margery Raistrick, who helped out in the office, answering enquiries and dealing with bookings; Mrs Greenwood, who dealt with the cash; Jack Wood, who came in to do the accounts, and Mrs Hollingdrake and a small part-time staff who served in the souvenir kiosk and dealt with admissions at the front door. Amy Foster, the archivist, continued to make regular visits to oversee the care and conservation of the Museum's collection. After Miss Foster's retirement, Margaret Jackson, who had worked briefly as her assistant, became the librarian. Margaret was undergoing dialysis, and died suddenly aged just twenty-eight. She was followed by Sally Stonehouse, who was plunged into her new role without advice from a predecessor. Mr Raistrick was a great support and Sally remembers the Parsonage as being a busy and happy place to work under Mr Raistrick's management.

Thursday was a day off for the Raistricks which they usually spent visiting Jean and her children, Chris and Judith, or Noreena and her family at Shipley. Mr Raistrick was a keen gardener and had soon planted a vegetable patch and rose beds in the garden at the back of the Parsonage. A swing was erected for his grandchildren, and whenever it snowed, they would enjoy sledding and building snowmen in the back field. The children also enjoyed helping their grandfather inside the Museum. They would keep Mrs Hollindrake company behind the stall selling souvenir items and help set out the postcards, and they loved to be shown items from the collection (particularly the 'little books') and watch the Brontës' long-case clock being wound.

Norman Raistrick's appointment coincided with the busiest period in the Museum's history. The series of brief, businesslike reports produced by Mr Raistrick throughout the 1970s shows how admission figures grew from 112,281 in 1970 to 214,033 in 1979. His report for 1972 records a figure of 147,096 visitors, with several television crews filming at the Parsonage, notably the BBC *Blue Peter* team. By 1973 the figure had risen to 195,142, something Mr Raistrick attributed to the power of television. This was the year that *The Brontës of Haworth* was screened by Yorkshire Television. The four-part drama was scripted by Christopher Fry and starred Alfred Burke as Patrick Brontë with Michael Kitchen as Branwell. Much of the drama was filmed at Haworth and featured the exterior of the Parsonage, with the interiors cleverly reproduced in the television studios. The Parsonage had also featured as the doctor's house in the popular 1970 film adaptation of E. Nesbit's *The Railway Children*. In 1974 the visitor figures reached 221,497 – the highest ever recorded. In 1976 the figure was 189,220, despite the fact that for several weeks in the busy summer period some of the rooms at the Parsonage had to be closed and the building was covered in scaffolding when the roof beams had to be replaced. Most of those who worked with Mr Raistrick describe him as 'unflappable', a useful quality when dealing with so many visitors.

These were heady days at the Parsonage, and with his interest in performance, Mr Raistrick enjoyed the many opportunities that came his way to meet well-known

characters from film and television and to give interviews himself. He was also very popular with members of the Brontë Society of Japan, whom he met when they visited Haworth. At the end of the day when all the visitors have gone home, the Parsonage is a very different place, and visitors often ask if the house is haunted. This question was asked by the writer Louise Brindley, who interviewed Mr Raistrick for an article shortly before his retirement:

> Is there a ghostly atmosphere at the Parsonage when all the visitors have departed, and the shutters are closed for the night? Norman Raistrick smiled at the question he has been asked so many times. Yes, he really did close the downstairs shutters every night, and never neglected to say, 'Goodnight, Mr Brontë.' 'But,' he chuckled, 'Mr Brontë never answered back!'

Norman Raistrick retired from the Parsonage on 21 March 1981 and his last report as Custodian was presented to the Society's AGM on Saturday 6 June of that year. He reported that 1980 had been another busy year, with a total of 204,912 visitors. He thanked the Museum staff and recorded that he had 'thoroughly enjoyed' his twelve years working at the Parsonage. He and his wife had moved out of the Parsonage flat in the previous December and into a new home, 25 Laburnum Grove, at Lees, provided for them by the Brontë Society Council. Their enjoyment of their

Norman Raistrick at work in his office at the Parsonage.

Merrall's office staff. Norman Raistrick is second from left. Next to him stands Margery Raistrick, wife of his nephew, Dennis.

new home was short-lived: Mrs Raistrick was taken into hospital and died there a few days later on 17 May 1981. Her death was a great loss to her husband and family. Norman Raistrick continued to take an interest in all Brontë-related matters and paid regular visits to the Parsonage. He remained at Laburnum Grove, close to the area in which he and Amy had spent their early lives, until his own death on 15 December 1982, aged seventy-seven.

Epilogue

The Raistricks were the last people to live on the Parsonage premises. After Mr Raistrick's retirement, Margery Raistrick, who had been working as his deputy, succeeded him as Custodian. Increasing visitor figures had led to an increase in staff, and the custodian's flat was converted into much-needed office space and a meeting room for the Brontë Society's Council.

The 1980s marked a period of radical change at the Parsonage. In 1982 the upper floor of the Wade extension was knocked through to create a large exhibition space (since 1928 the ground floor has been used as a research library-cum-curatorial office). During the closed period of 1987 a number of significant changes were made in the historic rooms to recreate, as far as possible, the appearance of the rooms as they were in the Brontës' day. Picture rails dating from the late Victorian period were replaced by dado rails, and period wallpapers, including one based on a design found in Charlotte's writing desk, were introduced in the original part of the house. Information gleaned from contemporary accounts and newspapers provided a wealth of information which was reflected in a new arrangement of furniture and household items. Items without a Brontë association were removed from display, although a half-tester bed, based on a drawing by Branwell, was specially commissioned for Mr Brontë's bedroom. None of the Brontës' beds have survived and the commission allowed the creation of a Brontë bedroom where original furniture and household linen could be displayed. The general appearance of the house reflected the 1850s, rather than the earlier period when Branwell, Emily and Anne were still alive, the decision justified by the fact that Charlotte put such a strong stamp on the house after the deaths of her siblings. She is believed to have made alterations in 1850, and most of the furniture and contemporary accounts date from that period.

The Parsonage has always been well maintained, but although there have been attempts to present it as the Brontës' home, no serious archaeological work has ever been carried out to allow for genuine historical veracity in its decoration. In

2011 Allyson McDermott and Crick Smith University of Lincoln were appointed to undertake an investigation into the original decorative schemes at the Parsonage, which could then be used to inform a new representation of the historic rooms of the house. Samples were taken from ceilings, cornices, wall-faces and woodwork. These removed paint samples were then mounted in cross section in a clear casting resin and surfaces polished back to reveal the accumulated paint layers. Wallpaper samples were separated and tested and all samples were viewed under high-powered binocular microscopes using a variety of lighting techniques. This provided useful data on the physical make-up of the paint which could then be compared with archival research and cross-referenced with other known samples, allowing for approximate dating of the accumulated layers by establishing trends in fashions and style within historic interiors for the target period.

At the time of writing, it is planned that in January 2013 paintwork throughout the Parsonage will be renewed, using bespoke paints based on the decorative archaeological analysis. Wallpapers based on those known to have hung in certain rooms of the Parsonage or on designs of the Brontë period are to be specially produced. Thanks to the efforts of the Brontë Society, many of the household contents have been returned to the Parsonage, and the restoration will provide the appropriate setting for the Parsonage Museum's wonderful collection of Brontë furniture and domestic artefacts.

Mr Brontë's study following the redecoration in January 2013. The analysis showed evidence of lead white paint having been used on the wall surfaces and woodwork in this room.

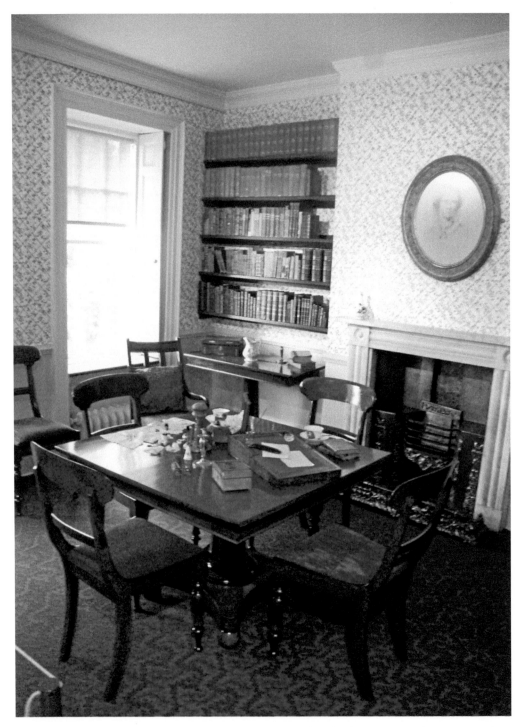

There was clear evidence of wallpaper having been used in the dining-room. The new period wallpaper reflects Mrs Gaskell's description: 'the prevailing colour of the room is crimson'.

The staircase with the Brontës' long case clock. The analysis found evidence of pale-blue distemper used on the walls of the hall and stairs, both before and after Charlotte's alterations, and this has now been reintroduced.

Sources and Further Reading

Baumber, Michael, 'That "Vandal Wade": The Reverend John Wade and the Demolition of the Brontë Church', *Brontë Society Transactions*, 22 (1997).

Baumber, Michael, *A History of Haworth* (Lancaster: Carnegie Publishing, 2009).

Bentley, Phyllis, 'From a Museum into a Home', *Brontë Society Transactions*, 13.69.339 (1959).

Broadhead, Helen, *The Horsfalls of Haworth Hall* (unpublished MS).

Chadwick, Esther Alice, 'Haworth Parsonage: The home of the Brontës', *The Nineteenth Century and After* (January 1928).

Dinsdale, Ann, *The Brontës at Haworth* (London: Frances Lincoln, 2006).

Dinsdale, Ann, 'Domestic life at Haworth Parsonage', *The Brontës in Context* (Cambridge: Cambridge University Press, 2012).

Edgerley, Mabel C., 'The Structure of Haworth Parsonage: Domestic Arrangements of the Brontës' Home', *Brontë Society Transactions*, 9.46.27 (1936).

Gaskell, Elizabeth, *The Life of Charlotte Brontë* (London: Smith, Elder & Co., 1857).

Green, Dudley (ed.), *The Letters of the Reverend Patrick Brontë* (Stroud: Nonsuch, 2005).

Greenwood, Robin E., *A History of the Greenwoods of Haworth* (unpublished MS, 1999).

Greenwood, Robin E., *West Lane and Hall Green Baptist Churches in Haworth in West Yorkshire: Their Early History and Doctrinal Distinctives* (unpublished MS, 2005).

Harland, Marion, *Charlotte Brontë at Home* (New York: G. P. Putnam's Sons, 1899).

Kellett, Jocelyn, *Haworth Parsonage: The Home of the Brontës* (Haworth: The Brontë Society, 1977).

Laycock, J. W., *Methodist Heroes in the Great Haworth Round 1734–1784* (Keighley: The Rydal Press, 1909).

Lemon, Charles, *A Centenary History of the Brontë Society* (Haworth: The Brontë Society, 1993).

Lemon, Charles, *Early Visitors to Haworth: From Ellen Nussey to Virginia Woolf* (Haworth: The Brontë Society, 1996).

Lock, John and Canon W. T. Dixon, *A Man of Sorrow: The Life, Letters and Times of the Rev. Patrick Brontë 1777–1861* (London: Nelson, 1965).

McDermott, Allyson and Crick Smith University of Lincoln, *The Brontë Parsonage Museum, Haworth: An Analysis of Decorative Finishes with Focus on the Brontë Period of Occupation* (unpublished report, 2011).

Mitchell, W. R., *Hotfoot to Haworth: Pilgrims to the Brontë Shrine* (Settle: Castleberg, 1992).

Smith, Margaret (ed.), *The Letters of Charlotte Brontë*, vol. 1 1829–1847; vol. 2 1848–1851; vol. 3 1852–1855 (Oxford: Clarendon Press, 1995, 2000, 2004).

Story, T. W., *Notes on the Old Haworth Registers* (Haworth: A. E. Hall, 1909).

Turner, Joseph Horsfall, *Haworth, Past and Present* (Brighouse: J. S. Jowett, 1879).

Steven Wood, *Haworth: 'A Strange Uncivilized Little Place'* (Stroud: Tempus, 2005).

Index